RotoVision

ROTOVISION
PRO-PHOTO SERIES

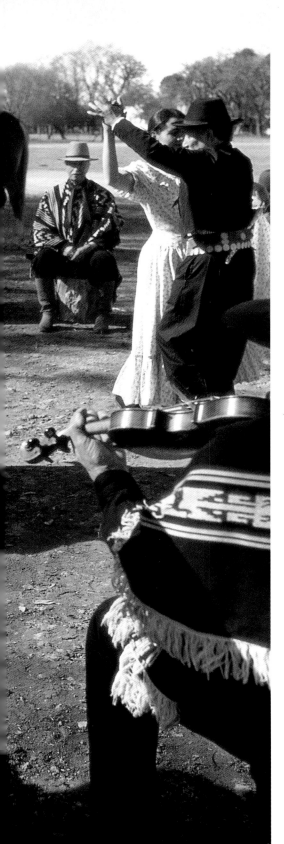

People in the Environment
Photography

Jonathan Hilton

Harrow College
Harrow Weald Campus, Learning Centre
Brookshill, Harrow Weald, Middx.
HA3 6RR 0208 909 6248

pro
photo

A RotoVision Book

Published and distributed by RotoVision SA
Rue du Bugnon 7
CH-1299 Crans-Près-Céligny
Switzerland

RotoVision SA, Sales and Production Office
Sheridan House, 112/116A Western Road
Hove, East Sussex BN3 1DD. UK
Tel: + 44-1273-7272-68
Fax: + 44-1273-7272-69
e-mail: sales@rotovision.com

Distributed to the trade in the United States by
Watson-Guptill Publications
1515 Broadway
New York, NY 10036

ISBN 2-88046-375-0

10 9 8 7 6 5 4 3 2 1

This book was designed, edited and produced by
Hilton & Stanley
63 Greenham Road
London N10 1LN. UK

Design by David Stanley
Illustrations by Brian Manning
Picture research by Anne-Marie Ehrlich

DTP in Great Britain by
Hilton & Stanley

Production and separation in Singapore by ProVision Pte. Ltd.
Tel: + 65-334-7720
Fax: + 65-334-7721

Photographic credits
Front cover: Aldo Sessa
Page 1: Damian Gillie
Pages 2–3: Aldo Sessa
Page 160: Llewellyn Robins
Back cover: Llewellyn Robins

Contents

1

Basic elements

2

Formal informal

3

Work and play

4

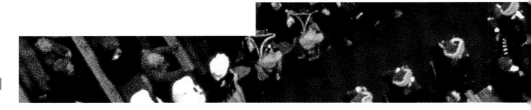

Working to a theme

Introduction

THE WORLD OF PORTRAIT PHOTOGRAPHY is wider than can be accommodated within the confines of the studio. Once you move outdoors, or into clients' homes or even where they work, you introduce an element of unpredictability into your photography. Certainly, in the studio you have total control over the intensity, mood, colour and atmosphere of the lighting. Within the limits of the background papers you have at your disposal or any painted flats you may have, you can also determine the surroundings in which your subjects are posed, where the shadows will occur or the highlights will appear. However, as many photographers will readily admit, working entirely in the studio can stifle your creative processes, limit your horizons and impart a sense of staleness to your work.

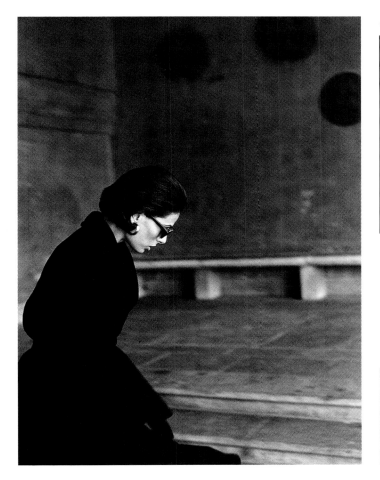

◀

A combination of the simplest of subjects and environments can have a tremendous impact. The rich tonal qualities of this portrait of a woman dressed in a black topcoat climbing the steps of an austere-looking public building in Stockholm, Sweden, lift her out of the setting, and the limited depth of field, which has rendered everything except the subject herself slightly out of focus, lends a tangible three-dimensional quality to the image.

PHOTOGRAPHER:	FILM:
Jörgen Ahlström	**ISO 125**
CAMERA:	EXPOSURE:
6 x 7cm	**$\frac{1}{125}$ second at f5.6**
LENS:	LIGHTING:
105mm	**Daylight only**

▲

The photographer's use of shadows has helped to imprint the environment onto the subject's body. Windows transmitting direct sunlight can be difficult to work with since the light tends to be of high contrast, creating bright shadows and intense highlights, except, as here, when a diffusing material is used to modify its effects.

PHOTOGRAPHER:
Jörgen Ahlström
CAMERA:
6 x 7cm
LENS:
90mm
FILM:
ISO 125
EXPOSURE:
⅟₃₀ second at f5.6
LIGHTING:
Daylight only

Natural and supplementary lighting

One of the major changes you will have to adjust to when shooting outside is not only the obvious one of the sheer variety of settings and environments at your disposal, but just how different each can appear depending on when you shoot. At different times of the day,

natural light can reveal or disguise, accentuate or subdue, paint the brightest of pictures or set the gloomiest of moods. Even minute to minute, the mood and atmosphere of natural light can shift radically as the weather changes or clouds drift into and out of the path of the sun. Each season, too, stamps its own identity on the environment, and each should be seen as an opportunity to create images that are vital and fresh.

There will be occasions, though, when the natural light is not on your side and you will have to supplement it with artificial lighting of some type. The obvious light source to use when on location is accessory flash. Although convenient, it is quite limited in both its lighting range and its applications. It can, when the subject is close and the surroundings are confined, generally increase lighting levels, but it is probably more useful for subtly altering contrast levels of nearby subjects by, say, relieving shadows that are too heavy in relation to adjacent highlights. When flash is used to illuminate a subject's face, it is best to hold it well off-camera in order to avoid the problem of red-eye.

Studio lighting units are another lighting option, and many models are designed for location shooting. These lightweight units pack down into their own carrying cases and can be set up in just a few minutes. If you will not have access to mains power, however, make sure your lights can be run off a car battery or a heavy-duty truck battery.

Approaches to the subject

Working outdoors opens up the possibility of some types of candid

photography. This does not necessarily mean that subjects are unaware of the camera's presence, only that they are not posed specifically for a particular shot or under the direction of the photographer. This approach often works very well with children, for example, since they can get on with their own activities while you pick shots off as the opportunities arise. When photographing people at work, too, where you want to show subjects simply getting on with whatever it is they do, adopting this type of approach should ensure natural-looking images. Be prepared, however, for a higher picture failure rate than in the studio: you may want to shoot more film than you would normally and pick the best from enlarged contact sheets.

Another approach to candid photography involves first finding the surroundings, a setting that is so good you simply have to use it, and then waiting to see what develops. Just what type of environment you feel is ideal depends on the type of mood or atmosphere you want your pictures to convey. To encapsulate modern city life, for example, you could set the camera up in front of a wall of graffiti; for a humorous effect or to make a social comment you might focus on a billboard advertisement and wait for the 'right' type of person to walk in front of it. Likewise, the folds in the hills of a rural landscape, an avenue of trees, or an attractive bridge could all be perfect environments depending on your intentions.

Formal portrait pictures can also work well when set outdoors. If, for example, wedding commissions feature significantly in your work calendar, spend as much time as it takes in you local area finding out which public parks look at

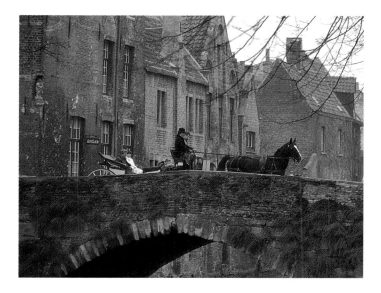

▲

A cold, misty light of a mid-winter's morning was illuminating the ancient brickwork and tiled roofs of the medieval town of Bruges, Belgium when the photographer decided to set his camera up and wait for likely subjects to appear to complete the scene. Whenever an attractive combination of subject and setting emerged within a predetermined 'shooting zone', he fired off a picture. Using a zoom lens it was possible to adjust the framing, shot by shot, without having to move too far from a single camera position.

PHOTOGRAPHER:
Jonathan Hilton
CAMERA:
35mm
LENS:
80–210mm zoom
FILM:
ISO 200
EXPOSURE:
⅟₆₀ second at f11
LIGHTING:
Daylight only

their best at particular times of the year. There may also be private homes in your general locality with exceptionally attractive grounds that you could use for a fee. Note, too, the location of buildings or landmarks with lots of character that might suit the mood of certain types of pictures – it might even be that by shooting from one specific spot you can compose a picture that has the appearance of rural idyll even though it is in the midst of an otherwise unremarkable urban environment. The camera does indeed lie.

Equipment and accessories

THE CAMERA FORMAT MOST OFTEN USED BY studio-based photographers is one of the popular medium format types: 6 x 4.5cm, 6 x 6cm or 6 x 7cm. These cameras produce a larger negative (or positive slide image) than the type used almost universally by amateur photographers and many professionals working on location – the 35mm camera. Generally speaking, the larger the original film image, the better the quality of the resulting print, since it requires less enlargement. The often relatively slow pace of a studio session also seems to favour the use of the larger format, since it tends to encourage a more considered approach to each shot. However, good-quality 35mm SLR cameras and lenses are capable of producing superb results, and they come into their own when hand-held shooting is necessary, for 'grabbed', candid-type shots, or when the session is perhaps unpredictable and the photographer needs to respond very quickly to the changing situation.

◄ This is the smallest of the medium format cameras and produces rectangular-shaped negatives or slides measuring 6 by 4.5cm.

◄ This is probably the best known of all the medium format cameras, producing square-shaped negatives or slides measuring 6 by 6cm.

Medium format cameras

This format, of which there are many variations, is based on 120 or 220 rollfilm. This type of film has a paper backing to protect the emulsion, and the familiar sprocket holes used on 35mm film are missing. The number of exposures per roll of film you can typically expect from the three most popular medium format cameras are:

Camera type	120 rollfilm	220 rollfilm
6 x 4.5cm	15	30
6 x 6cm	12	24
6 x 7cm	10	20

The advantage most photographers see in using medium format cameras is that the large negative size – in relation to the 35mm format – produces excellent quality prints, especially when big

This is the largest of the popular medium format cameras, producing rectangular negatives or slides measuring 6 by 7cm.
(A 6 x 9cm format is also available but is not commonly used.)

This type of 6 x 7cm medium format camera looks much like a scaled-up 35mm camera, and many photographers find the layout of its controls easier to use than the type on page 10.

This truly professional and versatile 35mm system camera, has an 8-frame-per-second motor drive, a choice of different metering systems; exposure and AF locks; exposure compensation; and a choice of aperture- or shutter-priority, fully automatic or fully manual exposure options.

enlargements are called for, and that this fact alone outweighs any other considerations. The major disadvantages with this format are that, again in relation to the 35mm format, the cameras are often heavy and slightly awkward to use; they are often not highly automated (although this can often be a distinct advantage); the camera bodies and lenses are expensive to buy; and you get fewer exposures per roll of film.

35mm single lens reflex cameras (SLRs)

Over the last few years, the standard of the best-quality lenses produced for the 35mm SLR has improved to the degree that for average-sized portrait enlargements – of, say, 20 x 25cm (8 x 10in) – results are superb.

The 35mm format is the best supported of all the formats, due largely to its popularity with amateur photographers. There are at least six major 35mm manufacturers, each making an extensive range of camera bodies, lenses, dedicated flash units, and specialized as well as more general accessories. Cameras within each range include fully manual and fully automatic models. Lenses and accessories made by independent companies are also available. Compared with medium format cameras, 35mm SLRs are lightweight, easy to use, generally feature a high degree of automation, and are extremely flexible working tools. For big enlargements, however, medium format cameras have the edge in terms of picture quality.

All 35mm SLRs use the same size of film cassette, of either 24 or 36 shots, in colour or black and white, positive or negative. Again because of this format's

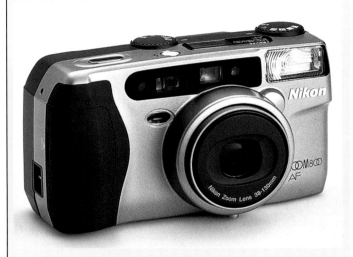
popularity, the range of films available is more extensive than for any other camera.

Lenses

When buying lenses, don't compromise on quality. No matter how good the camera body is, a poor-quality lens will take a poor-quality picture, and this will become all too apparent when enlargements are made. Always buy the very best you can afford.

One factor that adds to the cost of a lens is the widest maximum aperture it offers. Every time you change the aperture to the next smallest number – from f5.6 to f4, for example – you double the amount of light passing through the lens, which means you can shoot in progressively lower light levels without having to resort to supplementary lighting such as flash. At very wide apertures, however, the lens needs a high degree of optical precision in order to produce images with minimal distortion, especially toward the edges of the frame. Thus, lenses offering an aperture of f1.4 cost much more than lenses with a maximum aperture of f2.8.

At a 'typical' outdoor photographic session, you may need lenses ranging from wide-angle (for showing the environment as well as the subject, or for large-group portraits) through to moderate telephoto (to allow you to enlarge the size of the subject and hence alter the proportions of subject and setting). For 35mm cameras, the most generally useful lenses are a 28 or 35mm wide-angle, a 50mm standard, and about a 90 to 135mm telephoto.

As an alternative, you could consider using a combination of different zoom lenses. For example, you could have a 28–70mm zoom and another covering the range 70–210mm. In this way you have in just two lenses the extremes you are likely to use, plus all the intermediate settings you could possibly need to 'fine-tune' framing, composition and the relationship between subject and environment.

There is less choice of focal lengths

for users of medium format cameras. Lenses are also larger, heavier and more expensive to buy, but the same wide-angle, standard and telephoto lens categories apply. There is also a limited range of medium format zooms to choose from.

Accessory flash

The most convenient artificial light source when shooting on location is undoubtedly an accessory flashgun. Different flash units produce a wide range of light outputs, so make sure that you have with you the one that is most suitable for the type of area you need to illuminate. Bear in mind that flash used outdoors will not have the same effective range as when used indoors.

Tilt-and-swivel flash heads give you the option of bouncing light off any convenient wall or ceiling when you are working indoors. In this way, your subject will be illuminated by reflected light, which produces a kinder, more flattering effect. You need to bear in mind, however, that some of the power of the flash will be absorbed or dissipated by any of these intervening surfaces.

The spread of light leaving the flash head is not the same for all flash units. Most are suitable for the angle of view of moderate wide-angle, normal, and moderate telephoto lenses. However, if you are using a lens with a more extreme focal length, you may find the light coverage inadequate. Some flash units can be adjusted to suit the angle of view of a range of focal lengths, or adaptors can be fitted to alter the spread of light.

Long-life lighting

One of the problems of using accessory flash is the number of times the flash will fire before the batteries are exhausted. There is also the problem of recycling speed – the time it takes for the batteries to build up sufficient power in order to fire once more. With ordinary batteries, after as few as 30 firings recycling time may be so long that you need to change batteries (the fresher the batteries, the faster the recycling time). This is not only expensive, it is also time consuming. The solution to these problems is to use a battery pack. With some types of pack, when fully charged you can expect as many as 4,500 firings and a flash recycling time as low as 1/4 second – which is fast enough to use with a camera and motor drive. These figures do, of course, assume optimum conditions, such as photographing a nearby subject, with plenty of reflective surfaces nearby to return the light, and with the flashgun set to automatic.

▼

'Hammer-head' style accessory flash units are capable of producing high light levels and so are often used with heavy-duty battery packs. Always choose a model with a tilt-and-swivel head facility for a variety of lighting effects.

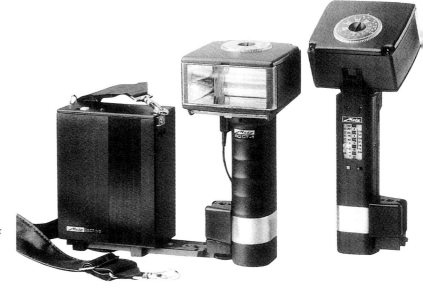

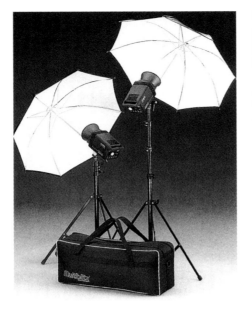

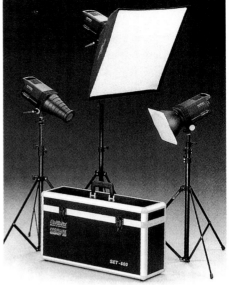

▲

These modern studio flash units have been designed with location work in mind. This set-up, comprising two lighting heads, umbrellas, and lighting stands, packs away into the flexible carrying bag illustrated.

▲

For a wider range of lighting effects, this set-up has three lighting heads, with add-on softbox, snoot and scrim, and three lighting stands. It all packs away into the case illustrated, which would easily fit into the boot or back seat of a car.

Studio flash

For the studio-based portrait photographer, the most widely used light source is studio flash. Working either directly from the mains or via an intervening control box/power pack, recycling time is virtually instantaneous and there is no upper limit on the number of flashes. However, as long as you have an appropriate power source, such as a heavy-duty car battery, there is no reason why this type of flash unit cannot be used when you are shooting outdoors on location.

A range of different lighting heads, filters, and attachments can be used to create virtually any lighting style or effect, and the colour temperature of the flash output matches that of daylight, so the two can be mixed in the same shot without any colour cast problems.

When more than one lighting head is being used, as long as one light is linked to the camera's shutter, synchronization cables can be eliminated by attaching slave units to the other lighting heads. Another advantage of flash is that it produces virtually no heat, which can be a significant problem when using studio tungsten lighting. To overcome the problem of predicting precisely where subject shadows and highlights will occur, which cannot be seen normally because the burst of light from the flash

is so brief, each flash head should be fitted with a 'modelling light'. The output from these lights is low and won't affect exposure, but it is sufficient for you to see the overall lighting effect with a good degree of accuracy.

▲

Reflectors can be made out of pieces of cardboard – white for a neutral effect or coloured for more unusual results. But professional reflectors, made from materials with different reflective qualities, allow you a greater degree of control, either in the studio or out on location. These are extremely lightweight and some fold down into a very compact size.

1

BASIC ELEMENTS

The **essential** environment

WHEN IT IS YOUR INTENTION to record in a photograph both the subject and the environment in which that person is seen, don't assume that the setting necessarily needs to be fully detailed in order to make a worthwhile contribution to the overall effect of the picture composition. This will almost certainly be true some of the time – part of the charm of a picture may be that you can read the labels on the bottles or stickers on the boxes in the background, for example, or see the cracks in the wall, the pattern on the curtains or the grain of the woodwork. But, equally, sometimes you can make a stronger pictorial statement by stripping the composition down to its bare, most important, essentials.

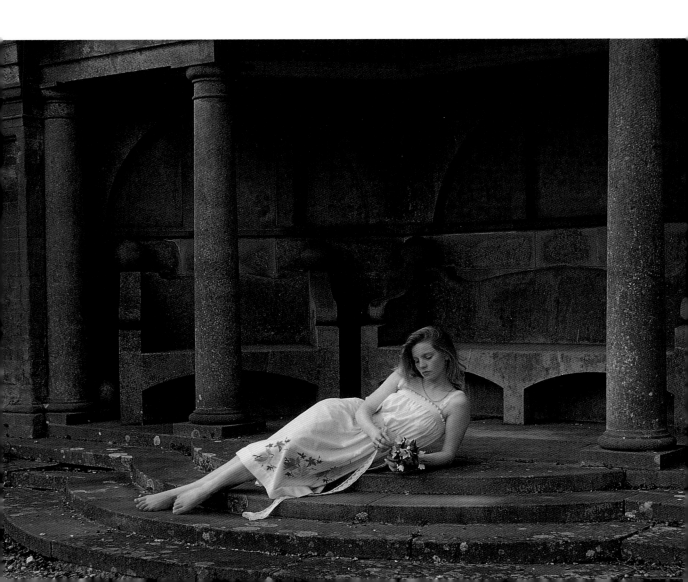

There are various devices at your disposal for simplifying a composition. The most important of these is your perception of the subject and setting. Whenever time allows, don't shoot from the first convenient camera position that presents itself. Rarely is there only a single good camera angle, so walk

◀

The light tone of the subject's dress and the angle of the daylight are the technical aspects of this photograph that have contributed to its success. It was the potential contrasts offered by the heavy blockishness of the oversized stone seats, the uncompromising lines of the pillars and steps with the vulnerable, softly rounded form of the subject that drew the photographer's attention to this particular setting. By positioning the woman on the steps where she would be fully illuminated by weak winter sunshine, he was able to set an exposure that recorded her pale skin and cream-coloured dress well while simultaneously underexposing the shadowy background by between $1^1/_2$ – 3 stops. To fully realize his perception, the photographer positioned a gold-coloured reflector to the left of the camera position, just beyond the angle of view of his lens. This was enough to bounce a little extra light on to the subject without significantly lifting the light levels in the much darker-toned surroundings.

PHOTOGRAPHER:
Llewellyn Robins
CAMERA:
6 x 4.5cm
LENS:
120mm
FILM:
ISO 100
EXPOSURE:
¹⁄₆₀ second at f8
LIGHTING:
Daylight only (boosted by gold-coloured reflector)

INTRODUCING A SENSE OF SCALE

The human figure does not have to be large in the frame to be important. Indeed, even when a figure takes up only a tiny part of the total image area, it draws immediate, and often disproportionate, attention to itself. Bearing this in mind can be vitally important in situations when the impact of a setting is dependent on the picture conveying the size and dimensions of the subject to the viewer. And what better way of doing this than including something of known size in the frame – such a the human figure.

Although positioned at the very top of the frame and taking up only a very small part of the image area, the tiny figure waving a piece of white cloth at the camera rivets the attention. As well as becoming the focal point of the composition, his white costume contrasting starkly with the blue of the sky above, his presence also conveys something of the vast empty surroundings and the fractured landscape on the west bank of the Nile near Luxor.

PHOTOGRAPHER:
Jonathan Hilton
CAMERA:
35mm
LENS:
28–80mm zoom (set at 28mm)
FILM:
ISO 200
EXPOSURE:
¹⁄₅₀₀ second at f11
LIGHTING:
Daylight only

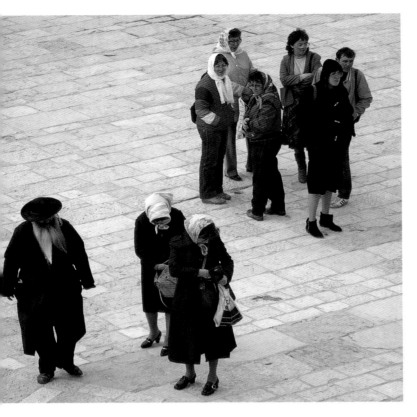

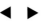

Camera angle is the telling feature of both these photographs, in which a high camera position looking down on the subjects has stripped away extraneous elements of the environment, leaving behind just the bare essentials. In the first image two groups of people in Jerusalem make a fascinating composition. The identical poses of the two foreground women searching in their bags while the bearded man in traditional costume looks on initially draws your attention. Then the curious stare of the two women in the background group takes you right back to the starting point. In the next shot, an Indian women glances upward at the camera position on a road bridge above as she stands knee-high in water washing one of her goats. A wider angle of view would have revealed the rest of the herd standing on the bank and a clutter of people washing, cooking and sleeping on the nearby bank. Although that also made the subject of another photograph, it is the simplicity of this one that is so powerfully evocative.

PHOTOGRAPHER:
Robert Hallmann
CAMERA:
6 x 4.5cm
LENS:
150mm
FILM:
ISO 100
EXPOSURE:
⅟₆₀ second at f11
LIGHTING:
Daylight only

around to see the subject from as many different angles as possible; look to see how the light falls or where the shadows occur; squat down to lower your perspective, or stand on a convenient chair, bench or railings to gain extra height, and see how the relationship between the subject and setting alters.

Other ways of controlling the picture content include focal length, depth of field and exposure. Changing the focal length determines the boundaries of the composition. Using a zoom lens, close in on the subject and you will see in the viewfinder the surroundings fall away on all sides; or zoom back to a wider setting until you can see through the camera just enough of the surroundings to bring about the effect you want to achieve. This is a quicker and more accurate method of framing a scene than the abrupt focal length changes brought about by changing from one prime (or fixed focal length) lens to another.

Having decided on the best camera position and focal length, turn your attention to the depth of field. Depending on the separation of the subject from the surroundings, select the most appropriate lens aperture to show the balance of sharp and soft detail that best communicates your intentions. Don't forget that every change in aperture has to be compensated for by a change in shutter speed – selecting a very small aperture for a fully detailed image throughout could mean using a shutter speed so slow that a tripod, or some other type of camera support, becomes necessary to avoid camera shake. Conversely, an open-aperture shot, to minimize depth of field, could require a shutter speed briefer than your camera can accommodate, and so a

compromise setting would then be
necessary. Finally, exposure can play a
vital role in establishing the relationship
of subject and setting, especially when
contrast is high and a decision has to be
made about which areas of the frame
are more important than others. If the
background is much darker than the
subject, for example, you can visually
suppress it in a photograph by setting
exposure for the subject alone.

Equally there may be occasions when
you want the environment to be the
main component of a photograph, and a
human figure can then be cast in more
of a supporting role.

PHOTOGRAPHER:
Jonathan Hilton
CAMERA:
35mm
LENS:
**80–210mm zoom
(set at 135mm)**
FILM:
ISO 200
EXPOSURE:
½₅₀ second at f8
LIGHTING:
Daylight only

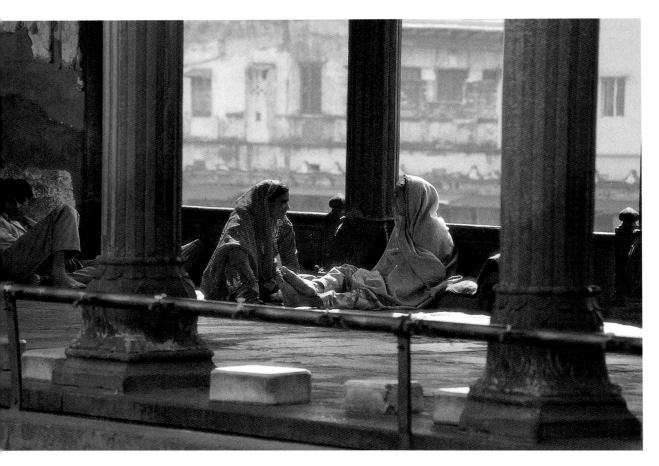

▲ ▶

PHOTOGRAPHER:
Jonathan Hilton
CAMERA:
35mm
LENS:
300mm
FILM:
ISO 200
EXPOSURE:
⅟₁₂₅ second at f11
LIGHTING:
Daylight only

In this example, you can see the importance of focal length in helping to show just those parts of the environment that act to support your subject or subjects. In the full-frame version, the two women can be seen sitting relaxed in the shade, happily talking to one another. To one side, the figure of a man is seen lounging. He has noticed the camera and is looking directly into the lens. On the other side, there is a view beyond the pillar, and both of these peripheral elements are distracting. In the cropped version, just enough of the environment has been retained to show the women in a meaningful context, which does not in any way distract the viewer's attention.

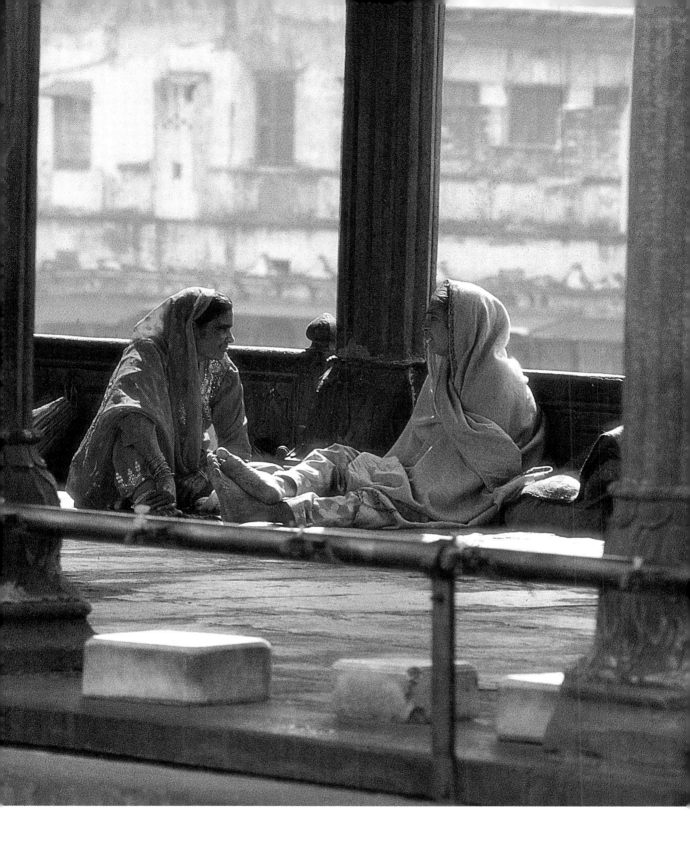

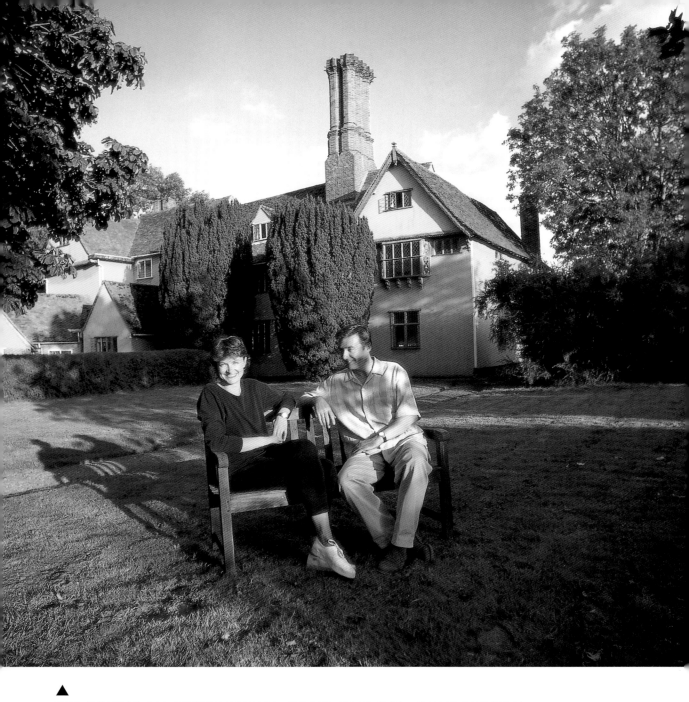

▲

In this double portrait the setting was a crucial part of the content
of the photograph, since it shows the owners of the house in the
background posed on a garden bench to take best advantage of
the honey-coloured afternoon sunlight. To achieve the depth of
field necessary to show all subject planes in crisp detail, the
photographer used a standard lens (for a medium format camera)
and selected a very small aperture.

PHOTOGRAPHER:
Robert Hallmann
CAMERA:
6 x 6cm
LENS:
80mm
FILM:
ISO 100
EXPOSURE:
1⁄60 second at f22
LIGHTING:
Daylight only

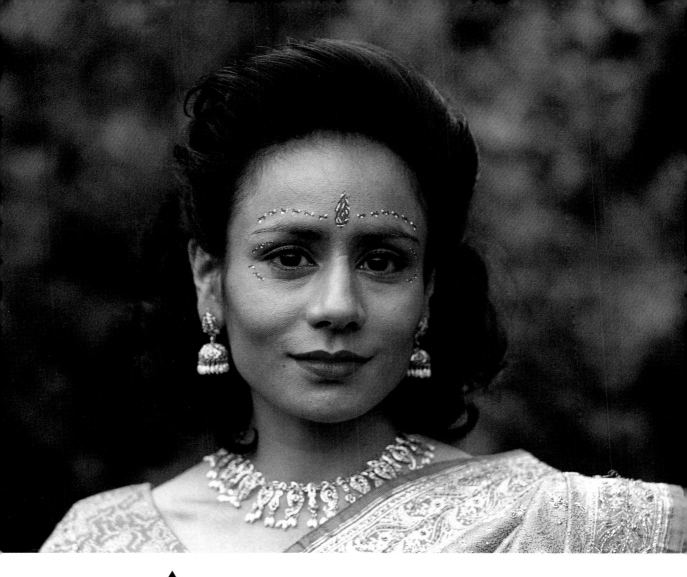

PHOTOGRAPHER:
Majken Kruse
CAMERA:
35mm
LENS:
135mm
FILM:
ISO 50
EXPOSURE:
¹⁄₁₂₅ second at f4
LIGHTING:
Daylight and accessory flash (plus diffuser)

Here the environment has been reduced to nothing more than a mottled background of near featureless green by the use of a wide aperture on a telephoto lens. As a result, all our attention is fixed on the woman, who is dressed and made-up ready for her marriage ceremony. The sun when this picture was taken was high in the sky and slightly behind the subject, and so contrast on her face was a little too flat. To overcome this, the photographer used a hand-held accessory flash fitted with a white plastic, clip-on lighting diffuser to soften the illumination and produce a more flattering effect.

Sometimes circumstances conspire to force you into making technical decisions that later turn out to be the best possible choice that could have been made. Faced with extremely low light levels at dusk, the photographer here had no choice but to use a wide aperture on his telephoto lens. This resulted in the depth of field reducing all of the background to a soft, almost abstract blur of colour and tone, but enough detail was still resolved for us to be able to identify the urban setting of the shot. The effect is quite magical and the contrast between sharp and unsharp imagery produces a powerful three-dimensional effect.

PHOTOGRAPHER:
Pascal Baetens
CAMERA:
35mm
LENS:
180mm
FILM:
ISO 800
EXPOSURE:
⅟₆₀ second at f4
LIGHTING:
Dim daylight and available street lighting

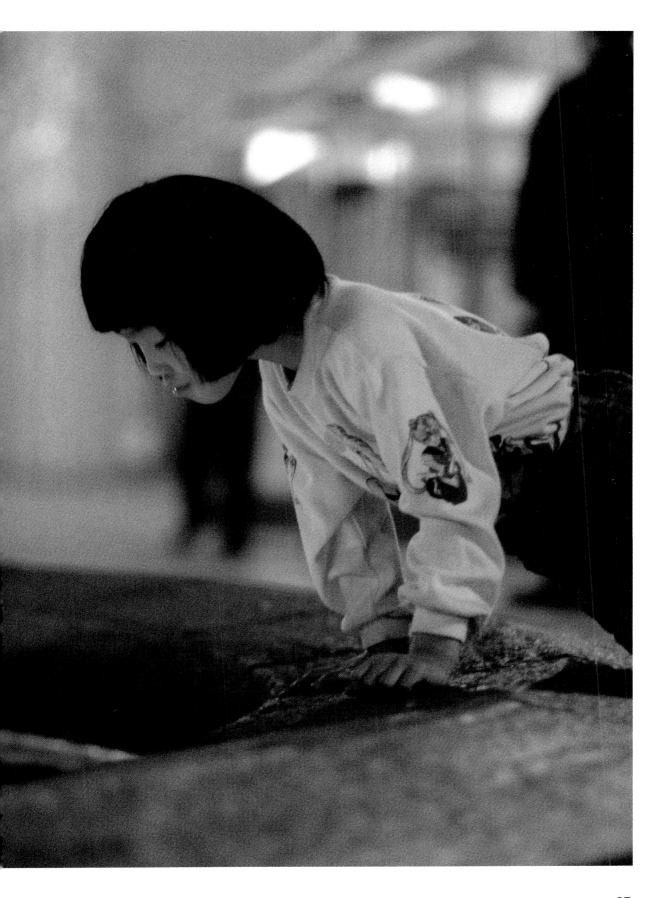

Backlighting

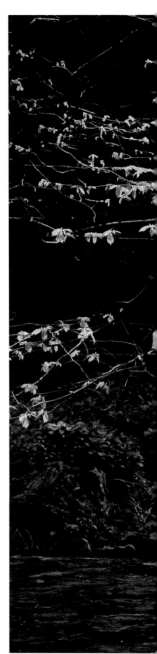

MOST 'RULES' IN PHOTOGRAPHY STEM FROM THE painterly traditions that existed at the time of the birth of photography, toward the end of the 19th century, or have evolved to circumvent the peculiarities and shortcomings of the technical workings of cameras, lenses or film. One of the most common examples of this latter type of rule is that photographers should always position themselves so that the sun, or any other principal light source, is at their backs when taking pictures. In this way, the side of the subject facing the camera would always be in full light. In essence, if the illumination is coming from behind the subject, it will most likely be shining directly into the camera lens. When this happens, not only could the different glass surfaces within the lens cause the light to flare and, hence, degrade the image, but the side of the subject facing the camera will also be in shadow and recorded as dark and underexposed.

If handled with care, however, backlighting (also sometimes termed *contre jour* lighting) can be one of the most useful and attractive of lighting effects. To overcome the problem of flare, never let the light shine directly into the lens. You could, for example, position the camera so that the subject itself shields the lens from any direct rays of light, or you could use overhead foliage, a nearby wall or the side of a building to cast a shadow over the front of the lens while the subject remains fully illuminated. If well designed and sufficiently deep, a screw-mounted or push-on lens hood can be extremely useful for preventing stray light reaching the lens from the sides of the camera and so causing image-degrading flare.

The other problem with backlighting is determining the 'correct' exposure for the subject. Your camera's light meter is likely to react to the light flooding into the lens by closing the aperture down and/or selecting a very brief shutter speed. The effect of this will be to underexpose the subject, since the side of the subject most directly facing the lens is in shadow. Many modern cameras have a backlighting exposure mode, but even if you take the time to select this feature it will not necessarily

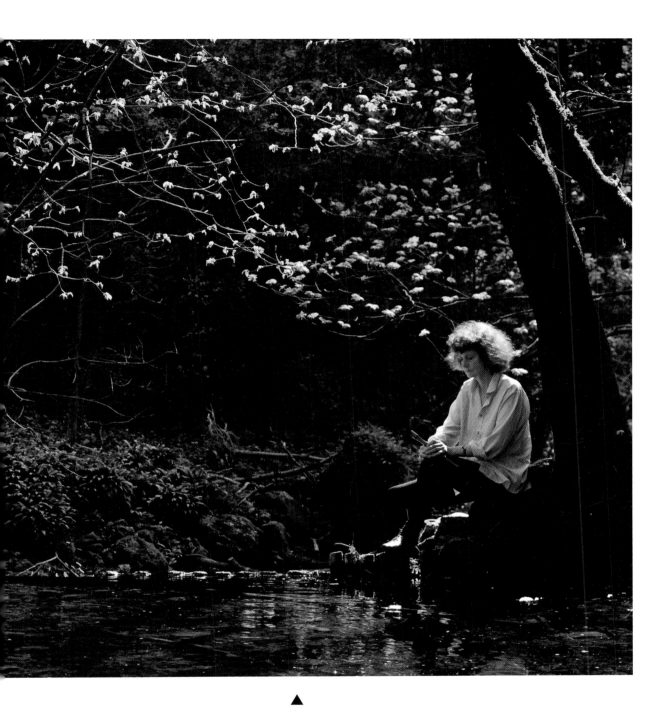

▲

make the correct exposure allowance for the particular circumstances and lighting intensities you are dealing with. If your camera has a spot-metering facility, then it is best to take your light reading as normal, assuming that your shadowy subject fully fills the centre of the frame – this is usually the part of the focusing

With the photographer at an angle to the subject, light entering the camera lens and causing flare was not a concern, yet the subject is beautifully backlit by autumn sunshine. Characteristically, when the back of the subject's hair is in full sunshine it glows out of the frame like a halo of illumination, and the translucent leaves on the nearly bare branches have taken on a delicate richness of colour.

PHOTOGRAPHER:
Llewellyn Robins
CAMERA:
6 x 4.5cm
LENS:
220mm
FILM:
ISO 100
EXPOSURE:
⅒ second at f8
LIGHTING:
Daylight only

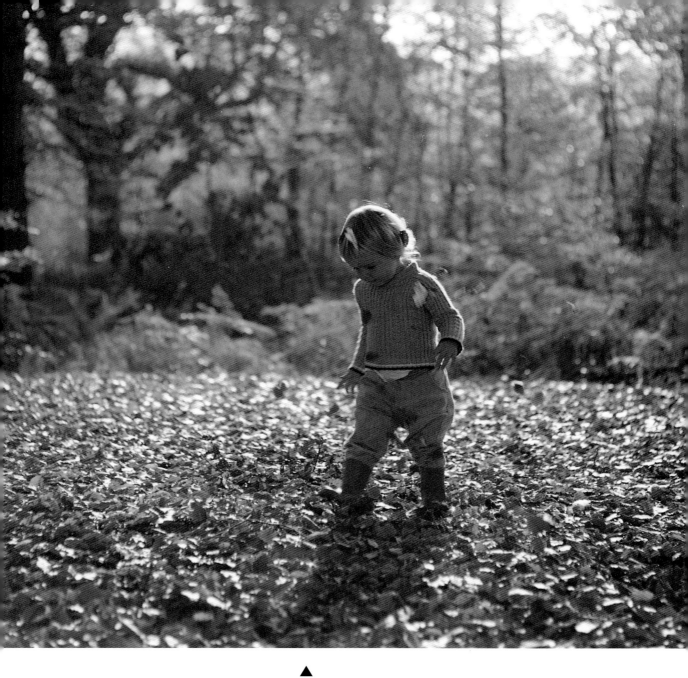

screen used by spot-metering systems (if in doubt, check your camera's user's manual). Alternatively, with an averaging exposure meter, move in close – or zoom the lens to its longest telephoto setting – so that the light reading completely excludes everything other than the subject. Then lock the recommended settings into the camera before recomposing the picture and

When the lighting is weak, as in this autumnal shot, and there is not a tremendous difference in intensity between the fully lit and shadowy parts of the scene, judging the correct exposure is not so much of a problem. The rimlighting around the child's head is particularly effective and helps to separate him tonally from the background.

PHOTOGRAPHER:
Llewellyn Robins
CAMERA:
35mm
LENS:
70-210mm
FILM:
ISO 100
EXPOSURE:
⅟₆₀ second at f5.6
LIGHTING:
Daylight only

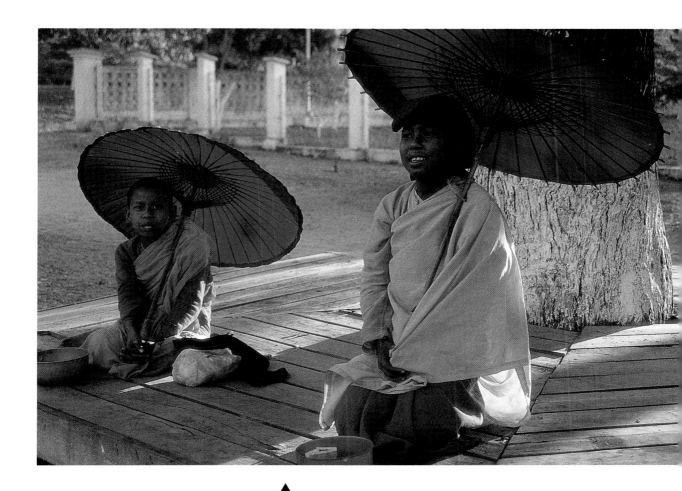

▲

releasing the shutter. If you cannot approach the subject or your zoom is not sufficient, take a light reading from, say, the back of your hand held in shadow and use that reading as the exposure basis for the shot. If time allows, bracket exposures as a safeguard.

Because they were lit from the rear and were sheltering under sun shades, judging correct exposure for these two young Buddhist nuns was problematic. While following their religious way of life, Buddhists rely on the charity of total strangers for their food, money and all their other daily requirements, and so it would have been neither rude nor insensitive to have approached them with the camera for a close-up exposure reading. However, rather than take the chance of spoiling the mood of the scene the photographer zoomed in to the maximum telephoto setting of his lens and filled the frame with the pink shawl of the nearer of the two figures. Then, keeping the autoexposure lock button depressed, he zoomed the lens back to a wider setting so that the environment of the shot was established once more before shooting.

PHOTOGRAPHER:
Jonathan Hilton
CAMERA:
35mm
LENS:
80–210mm zoom (set at 135mm)
FILM:
ISO 200
EXPOSURE:
1⁄60 second at f5.6
LIGHTING:
Daylight only

Depth of field

HOW MUCH OF THE SETTING YOU SHOW along with your subject, and from what angle you shoot to ensure that certain elements of the environment are included in the frame while others are excluded, are entirely subjective decisions to do with composition that all photographers need to make before taking each picture. However, having decided on precisely what to show, your next decision should be the degree of clarity you want the setting to have in relation to the subject.

In some situations, the setting may be of crucial importance, adding layers of meaning, texture and context to the subject. But even if this is the case, you may still want to differentiate the various elements of the composition by showing, for example, the subject critically sharp while the background appears at least to some degree out of focus, or

PHOTOGRAPHER:
Pascal Baetens
CAMERA:
35mm
LENS:
28mm
FILM:
ISO 800
EXPOSURE:
⅙₀ second at f5.6
LIGHTING:
Natural daylight only

Showing the human figure in a broad landscape, such as you can see here, works well when both the land and sky have sufficient detail to hold your attention. The blue of the sky and well-defined clouds make a perfect backdrop for the cattleman and his dog, while the quietly observing cows and rock-strewn hills leading down to the distant lake encourage the exploration of the whole frame. Settings such as this can pose certain technical problems when there is too great an exposure difference between land and sky, leading to underexposure of one or overexposure of the other.

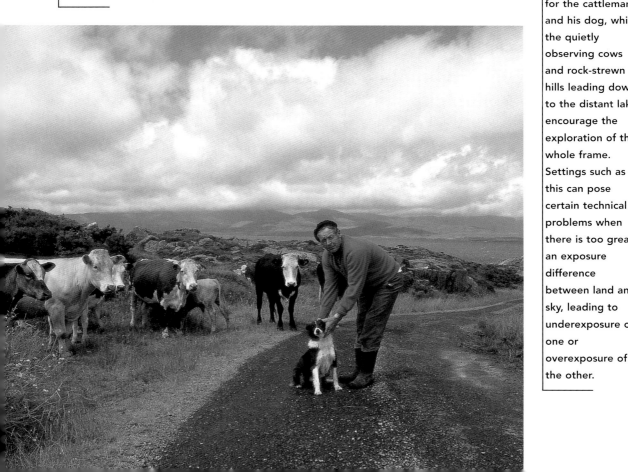

'softer'. In other situations, the setting may be positively distracting, and if you can't change camera position or the subject in order to modify its effect on the image, you may want to reduce it to an abstract coloured or tonal blur.

Just how sharp elements at different distances from the camera appear in the picture depends on what is known as the 'depth of field'. This is the variable zone of acceptably sharp detail that exists both in front of and behind the actual point the lens is focused on. But bear in mind that there will probably be as many occasions when you want the maximum amount of sharpness in an image, from the near foreground to the far distance,

CONTROLLING DEPTH OF FIELD

The three common ways in which you can control depth of field are through your choice of lens focal length, lens aperture and camera-to-subject distance.

Essentially, in order to maximize the zone of acceptably sharp detail in an image, use the shortest possible focal length lens (or setting on a zoom lens); use the smallest possible aperture light levels will allow; and increase the focus distance. This advice must, of course, be adapted to suit the particular circumstances you find yourself working in. For example, there is little point in selecting an aperture such as f22 to maximize depth of field if you then need to set a shutter speed of, say, 1/15 second to compensate, and thereby introduce the near certainty of camera shake. Likewise, a 28mm wide-angle lens will give you a generous depth of field at all apertures, but the subject may then appear insignificantly small in the frame. In order to minimize the depth of field, use the longest feasible focal length lens as close as possible to the subject and select the widest possible aperture.

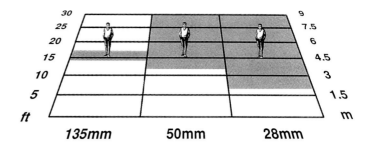

This diagram illustrates the effects on depth of field brought about by using three very common focal length lenses. In each case, the lens aperture was f8.

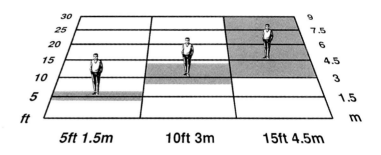

For the purposes of this illustration, changes in depth of field are the result of changing only the distance between the camera and the subject. In each case, the lens is a standard (for 35mm cameras) 50mm and the aperture is f8.

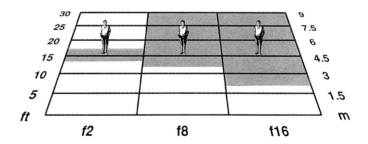

Here you can see the depth of field changes brought about by changing only the lens aperture on the same focal length lens. The largest aperture produces the shallowest depth of field, while the smallest gives the most extensive.

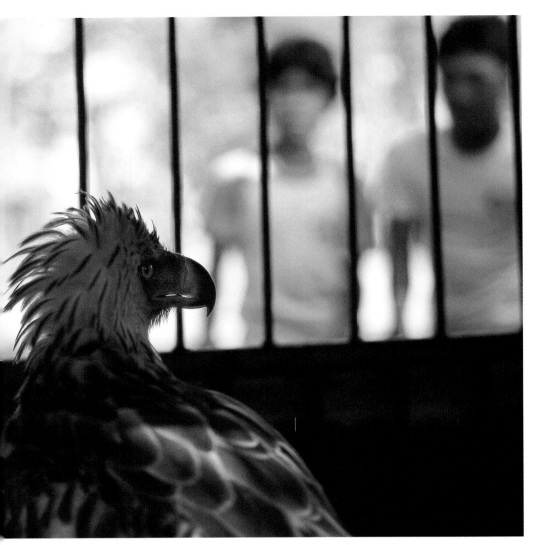

PHOTOGRAPHER:
Robert Hallmann
CAMERA:
6 x 6cm
LENS:
180mm
FILM:
ISO 100
EXPOSURE:
$\frac{1}{125}$ second at f4.5
LIGHTING:
Daylight only

▲

as there will be times when you want to record a more selectively focused view. Thus, knowing how to control depth of field is crucial to your realization of the final image.

An unusual approach has been taken by the photographer for this picture of a caged eagle. The cage had open bars on both sides and by using a moderately long lens, focusing on the bird and selecting the maximum available aperture, the resulting limited depth of field has rendered the background figures completely out of focus. Timing was important in order to record the faces of the moving figures unobscured by the bars of the enclosure.

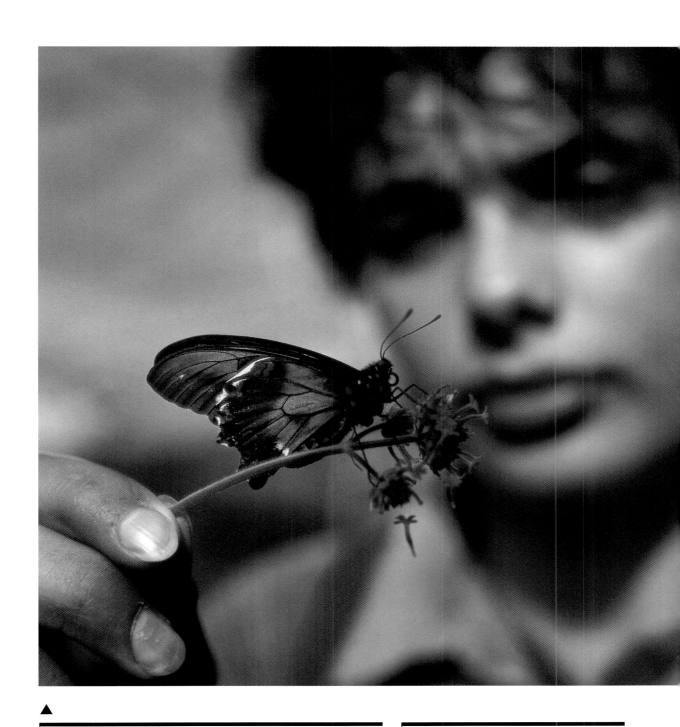

▲

The minimum focusing distance of many lenses would make this type of image impossible to take, unless it is a specialist close-focusing macro lens or has a macro mode. To achieve this result, the photographer used a supplementary close-up filter on the front of a standard lens. A feature of all close-up photography is an extremely limited depth of field – even with relatively small apertures. Using an SLR (35mm or medium format) means that you can monitor the exact image framing no matter what lens, or combination of lens and filters, is attached to the camera.

PHOTOGRAPHER:	FILM:
Robert Hallmann	**ISO 100**
CAMERA:	EXPOSURE:
6 x 6cm	**⅟₆₀ second at f8**
LENS:	LIGHTING:
80mm (plus close-up filter)	**Daylight only**

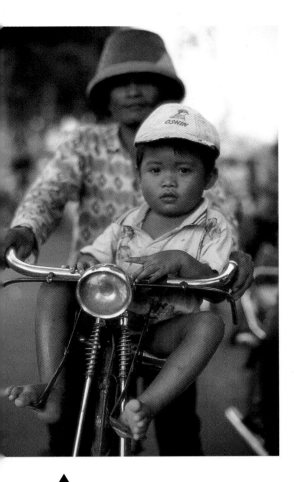

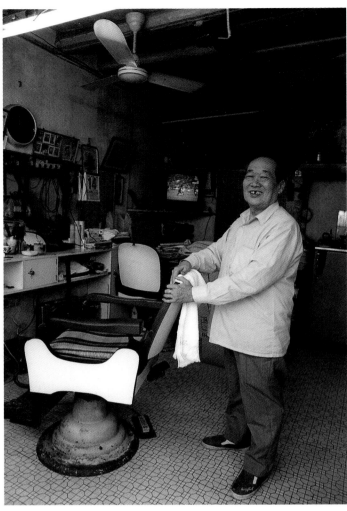

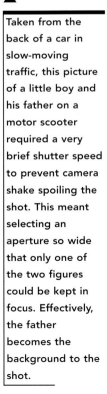

Taken from the back of a car in slow-moving traffic, this picture of a little boy and his father on a motor scooter required a very brief shutter speed to prevent camera shake spoiling the shot. This meant selecting an aperture so wide that only one of the two figures could be kept in focus. Effectively, the father becomes the background to the shot.

PHOTOGRAPHER:
Edward Tigor Siahaan
CAMERA:
35mm
LENS:
135
FILM:
ISO 100
EXPOSURE:
⅟₅₀₀ second at f2.8
LIGHTING:
Daylight only

It is the complexity of the detail seen in the environment of the barber's shop that makes this portrait so fascinating. The half-finished ceiling, decrepit-looking chair, ancient ceiling fan, bottles, electric flexes, mirrors, calendar, pictures and mementos, and not forgetting the television on but ignored in the corner – all of these the eye hungrily devours before settling happily on the figure himself. Depth of field easily extends throughout the shot, giving everything equal clarity, but the fall-off in lighting towards the rear of the room helps to project the brighter lit subject forward in the frame.

PHOTOGRAPHER:
Pascal Baetens
CAMERA:
35mm
LENS:
28mm
FILM:
ISO 800
EXPOSURE:
⅟₃₀ second at f5.6
LIGHTING:
Natural window light only

The considered use of different lens and aperture combinations allows you to manipulate depth of field in order to produce subtle shades of emphasis within a picture. Here, the photographer has used a telephoto lens in order to avoid approaching the subject too closely. By selecting a moderately wide lens aperture and focusing extremely carefully, he has ensured that the camel driver is pin sharp, while the camel's head and neck, only a few feet behind, are much softer. Had a smaller aperture been used – resulting in the man, camel and house wall all being equally sharp – there would have been no obvious point of interest in the composition and the rich detailing in the man's face and turban would have had less presence and impact.

PHOTOGRAPHER:
Frits Jansma
CAMERA:
6 x 4.5cm
LENS:
180mm

FILM:
ISO 50
EXPOSURE:
½₅₀ second at f4
LIGHTING:
Daylight only

Framing decisions

WHEN THE ENVIRONMENT IN WHICH THE SUBJECT is posed is a vital component of the image, you need to take care that the subject is not unduly diminished – unless it is your intention to use the human figure as simply one of the components within a particular setting.

Framing can be considered on two levels. First, it represents the boundaries of the composition – what is included in the picture and what is left out. This aspect of framing is principally influenced by your choice of camera angle and lens focal length (or focal length setting on a zoom). There are many factors that could influence your choice here, such as the distribution of colours or tones in the setting and subject; areas of highlight and shadow, ensuring that, if relevant, you show or omit whatever it is your subject is reacting to, depending on the type of image you want to portray; or

CROPPING THE IMAGE

In ideal circumstances, all your framing decisions should be made before you take the picture. In this way, you will be able to print from the entire image area of the film, which helps to ensure that print quality is as good as it can be when big enlargements are called for. If you find it difficult to envisage how the picture area will look when isolated from its surroundings, form your thumbs and forefingers into a frame through which to view the scene. L-shaped pieces of cardboard also serve the same purpose by helping you to previsualize the framing of a shot – if, that is, you have the time to use them. Not uncommonly, however, it is only when you view your finished prints or projected transparencies that you see how framing could have been improved by cropping out extraneous or distracting parts of the image. It could be that by radically cropping an image you end up with a picture shape that does not correspond to any type of standard format and so could not be created in the camera before shooting, but this really will not be detrimental if the final image is strengthened by the cropping process.

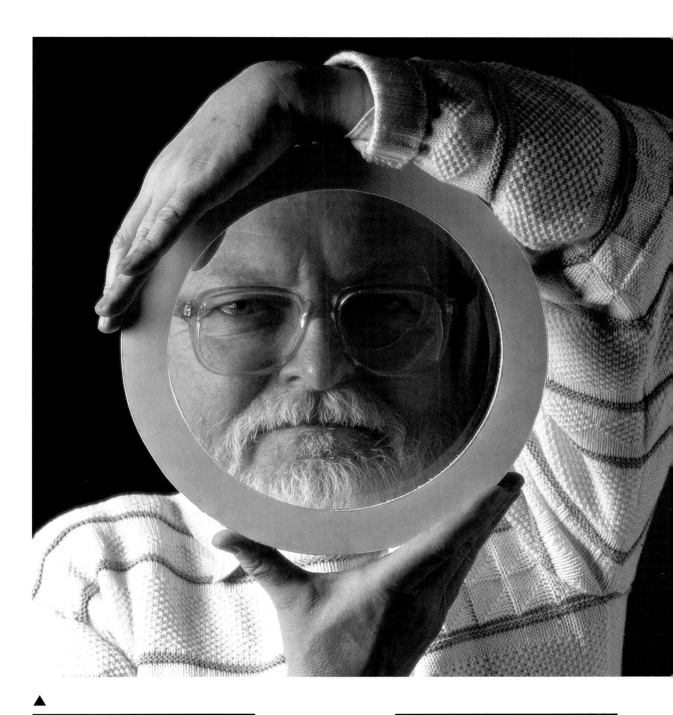

▲

The simplicity of this frame – a circular
cardboard filter mount used on the front
of a lighting unit – lends great strength to
this picture of a fellow photographer. The
subject's hand and arm at the top of the
filter have been carefully positioned to
block off all view of the top of his head, so
all you can see of his face is that showing
through the filter's aperture.

PHOTOGRAPHER: **Robert Hallmann** CAMERA: **6 x 6cm** LENS: **200mm** FILM: **ISO 200**	EXPOSURE: **⅟₆₀ second at f11** LIGHTING: **Tungsten-halogen spotlight**

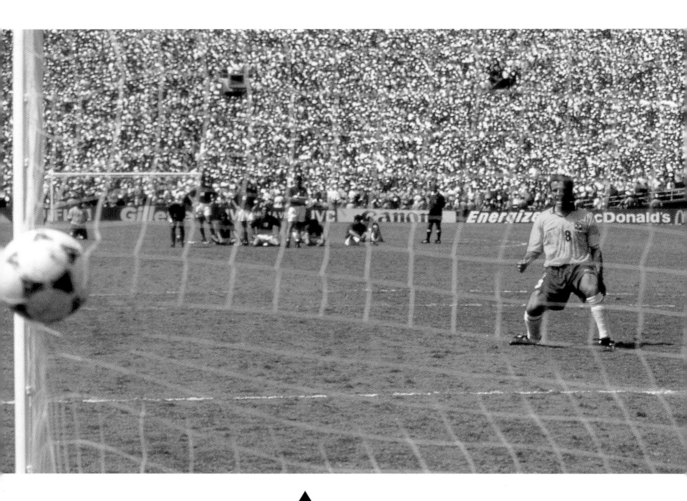

some feature in the setting that creates a strong boundary within which you can compose all the subject elements – a tree, for example, archway, edge of a building, pole or post.

The second aspect of framing involves the manipulation of the elements within the picture area to concentrate attention on your subject, or on just some part of your subject. For example, a person's long hair could be used to accentuate his or her face; foreground foliage might make the perfect frame for a portrait photograph; a shadowy background could help to

The captain of the Brazilian football team can be seen here scoring one of the penalties that resulted in Italy's loss during the 1994 World Cup final, and what better camera position could there be to capture the atmosphere of the event? Using the goal post and net to frame the subject, we can see the ball bulleting into the back of the net, the joy on the Brazilian's face, the dejected postures of the opposition, and the sea of expectant spectators behind.

PHOTOGRAPHER:
Popperfoto
CAMERA:
35mm
LENS:
28mm
FILM:
ISO 200
EXPOSURE:
1/500 second at f8
LIGHTING:
Daylight only

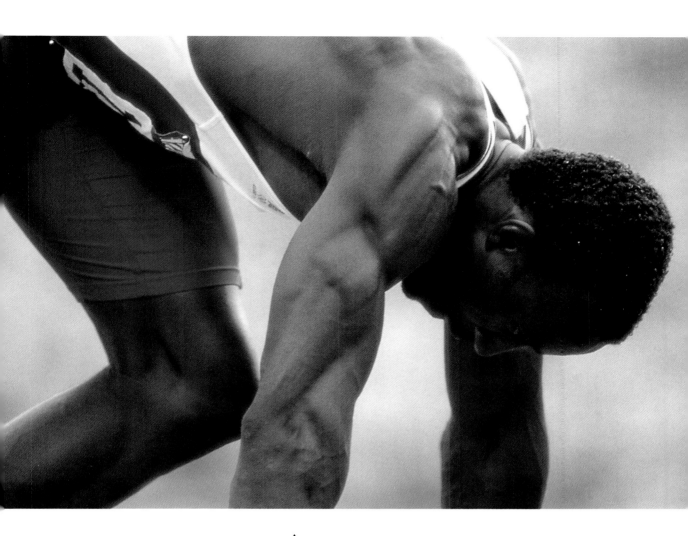

flag a light-toned figure who is positioned in front of it; or you could use depth of field to throw surrounding elements out of focus, leaving your subject as the only sharply rendered part of the composition.

▲

The extremely narrow angle of view of a long telephoto lens has cropped in tightly on British champion runner Linford Christie to produce a dramatically composed image. As you can see, the depth of field is so shallow with lenses such as this that the potentially distracting background consisting of rows of spectators on the far side of the track have simply been made to disappear. However, the weight of long lenses makes a tripod, or some other form of support, essential in order to avoid camera shake.

PHOTOGRAPHER:
Popperfoto/Dave Joiner
CAMERA:
35mm
LENS:
600mm
FILM:
ISO 200
EXPOSURE:
⅟₆₀ second at f22
LIGHTING:
Daylight only

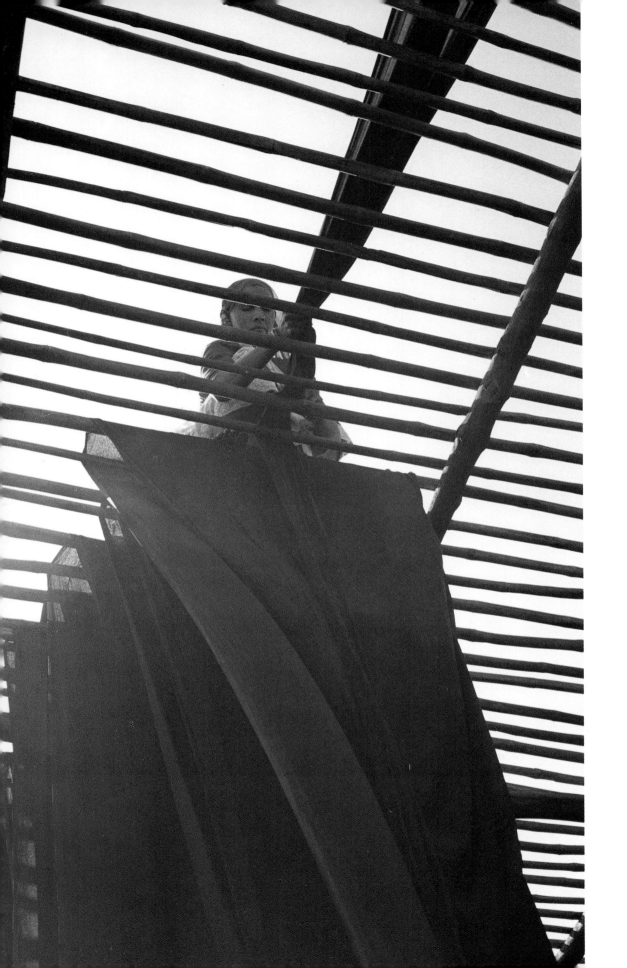

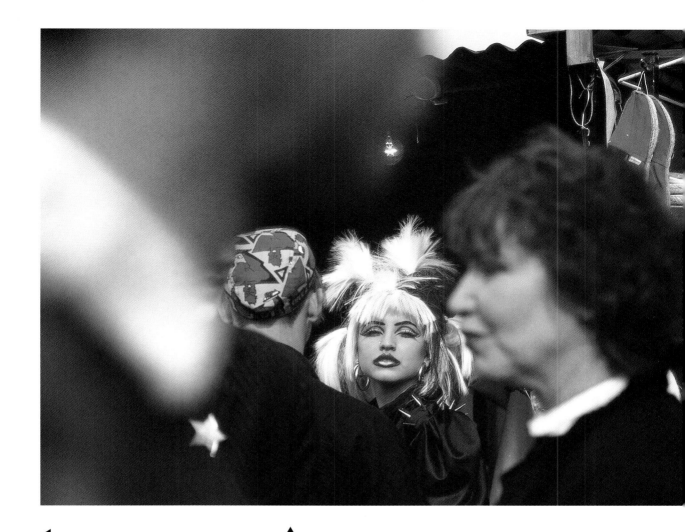

◀

A grid of bamboo poles on which lengths of silk cloth are drying forms the frame for this portrait. Although the angle is deceptive, there is about 1m (3ft) between the poles and the subject's face, and most autofocus cameras would focus either on the poles themselves or the subject's hands, throwing the face out of focus as a result. In such situations it is vital to ensure that your autofocus is doing what you want it to do or, if necessary, switch it off and focus manually.

▲

The bizarrely-dressed and made-up subject of this photograph has been cleverly framed by the out-of-focus figures on either side of her. With subjects moving randomly across the field of view of a lens, as they were in this situation, there is always an element of luck involved – other shots taken at the same time, for example, show the subject partially obscured. If you are using an autofocus lens, focus on the main subject and then lock the setting into the camera before shooting. Otherwise, the lens may assume that one of the foreground figures is, in fact, the principal subject and refocus accordingly. To limit depth of field, open up the aperture to the widest available on your particular lens.

PHOTOGRAPHER:
Frits Jansma
CAMERA:
6 x 4.5cm
LENS:
80mm
FILM:
ISO 100
EXPOSURE:
¹⁄₆₀ second at f11
LIGHTING:
Daylight only

PHOTOGRAPHER:
Robert Hallmann
CAMERA:
6 x 4.5cm
LENS:
220mm
FILM:
ISO 100
EXPOSURE:
¹⁄₅₀₀ second at f4
LIGHTING:
Daylight only

Off-centre framing, especially when it is radically off-centre as here, immediately attracts the attention of the viewer, as does the colour contrast between the figure's white clothing and the bright orange of the steps. The picture had to be taken quickly, since the subject, Pope John Paul II, was about to descend the steps to be greeted by a party of dignitaries waiting just out of view of the camera. The photographer still had the presence of mind to ensure that the Pope's fingers were not cropped off at the top of the frame and that he was looking inward toward the free space in the frame. An awkward effect is usually created when a figure positioned at the edge of the frame is looking out of the picture.

PHOTOGRAPHER:
François Lochon/FSP/ Gamma
CAMERA:
35mm
LENS:
500mm
FILM:
ISO 100
EXPOSURE:
¹⁄₂₅ second at f11
LIGHTING:
Daylight only

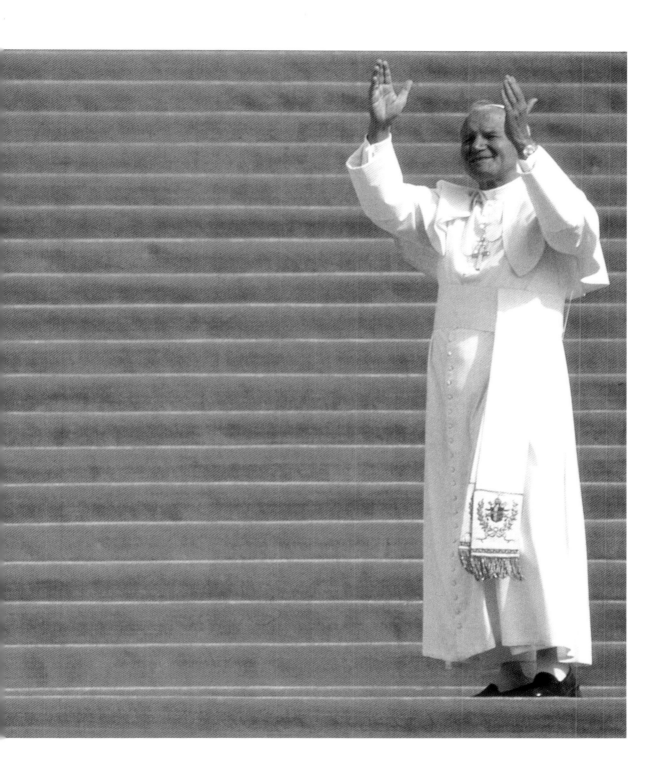

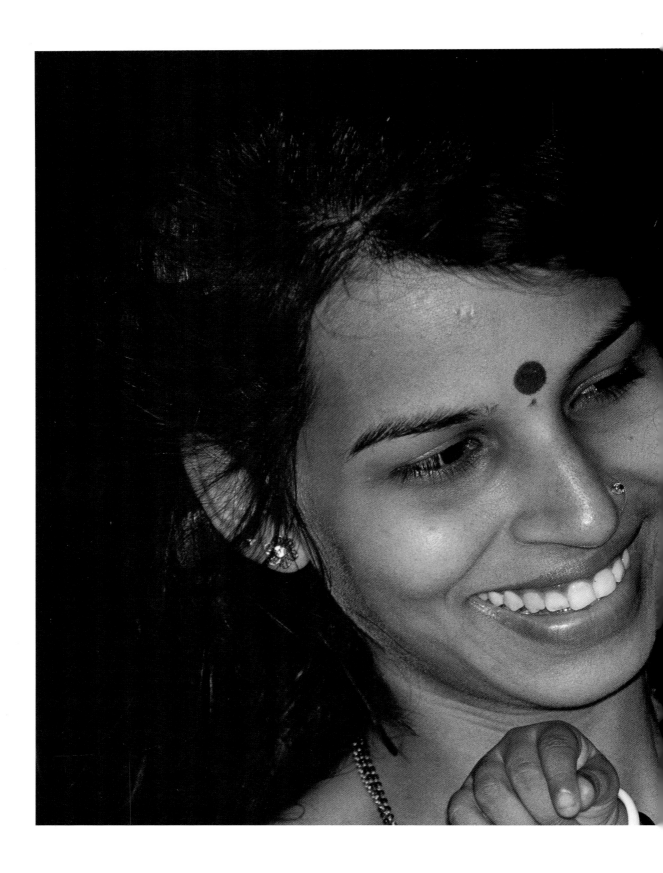

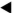

Faces framed by their own glossy black hair, mother and daughter pose, perhaps a little apprehensively on the part of the little girl, for the photographer. Taken informally using nothing more than accessory flash, the photographer used a diffuser over the flash head to soften the lighting effect without taking the critical edge off the subject detail.

PHOTOGRAPHER:
Frits Jansma
CAMERA:
6 x 4.5cm
LENS:
105mm
FILM:
ISO 100
EXPOSURE:
$\frac{1}{125}$ second at f4
LIGHTING:
Accessory flash (plus diffuser)

Recording movement

A REFLEX RESPONSE WHEN PHOTOGRAPHING MOVING SUBJECTS is to set the fastest available shutter speed in order to record as sharp an image as possible. Results can be startling when, for example, you see a figure frozen in mid-leap or water droplets strung out in the air as if a crystal necklace. However, as dramatic and clinically detailed as these images can sometimes be, they do not correspond to the way we normally see movement – at least not with the unaided eye.

Another approach to recording subject movement is to set a shutter speed that is long enough to allow the subject to move while the shutter is open and the film is being exposed. A shutter speed of, say, $1/60$ second may cause a sprinter to blur and streak on the resulting picture, while a walking figure could be recorded with no hint of movement at all at the same shutter speed. When you are recording movement, much also depends on the size of the image in the frame (which depends on subject distance and lens focal length) and the direction of travel of the subject in relation to the camera.

FACTORS AFFECTING THE RECORDING OF SUBJECT MOVEMENT

A number of factors determine the way a moving subject is recorded by the camera:

- The larger the subject is in the camera's viewfinder the more obvious any subject movement appears on the resulting print or slide. A walking figure in the middle distance recorded by a wide-angle lens may appear pin sharp, while that same figure (using the same shutter setting) walking at the same speed may appear soft and indistinct when photographed with a telephoto lens.
- A subject moving directly towards or away from the camera position can be recorded sharply using a relatively slow shutter speed.
- A subject moving at 90° to the camera position requires the fastest relative shutter speed if it is to be recorded sharply.
- A subject moving at 45° to the camera position requires a moderately fast shutter speed if it is to be recorded sharply.

PHOTOGRAPHER: **Robert Hallmann**	FILM: **ISO 200**
CAMERA: **6 x 6cm**	EXPOSURE: **⅕ second at f22**
LENS: **180mm**	LIGHTING: **Daylight only**

▶

To take this image of a running child and her dog, the photographer set a very slow shutter speed and panned the camera rapidly to keep the subject in roughly the same position in the frame throughout the exposure.

PANNING

By pivoting the camera to keep up with a moving subject during the actual exposure you will record a relatively sharp image of the subject while blurring all stationary parts of the scene. The slower the shutter speed, the more the subject will blur, while the faster you pivot the camera the more the background will blur. Line the subject up in the viewfinder before pressing the shutter release and then, during the exposure, move the camera to keep the subject in the same relative position in the frame until you hear the shutter close. With an SLR camera, the viewfinder will blank out as the internal mirror flips up to allow light through to the focal plane shutter, and so you may need to sight the subject over the top of the camera. As with a golf swing, keep the camera moving even after the shutter has closed for a smooth result.

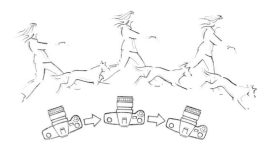

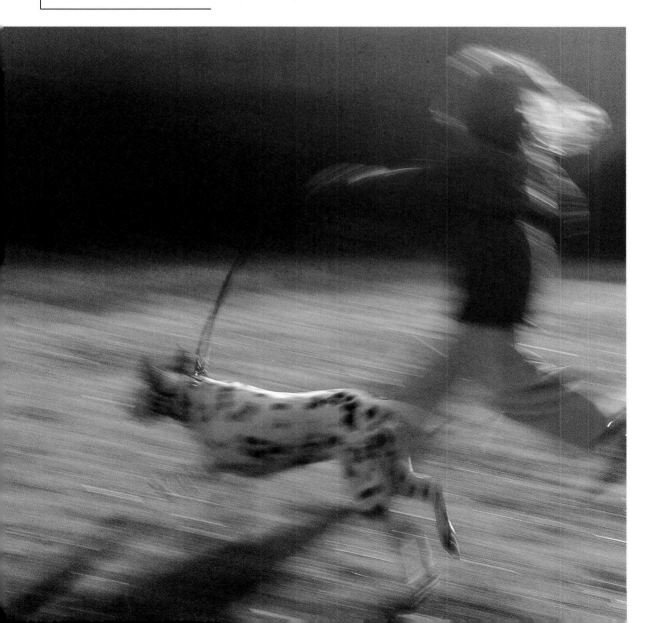

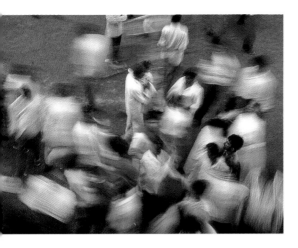

▲

To bring about a radical change in subject appearance, the photographer in this example of subject movement set up the camera on a firm support (the railing of a hotel balcony), lined up the crowd below in the viewfinder and selected a small lens aperture. The effect of this was to force the camera's autoexposure system to compensate by setting a very slow shutter speed in the rapidly diminishing light of dusk. The degrees of blur evident in the subjects depend entirely on the speed they were moving while the exposure was taking place – the fastest moving are most blurred, while some figures remained so still that blur is hardly noticeable. Always take two or three frames when experimenting with this technique, since you can never guarantee what results will look like in advance.

PHOTOGRAPHER:
Jonathan Hilton
CAMERA:
35mm
LENS:
80–210mm zoom
(set at 150mm)
FILM:
ISO 200
EXPOSURE:
⅛ second at f11
LIGHTING:
Daylight only

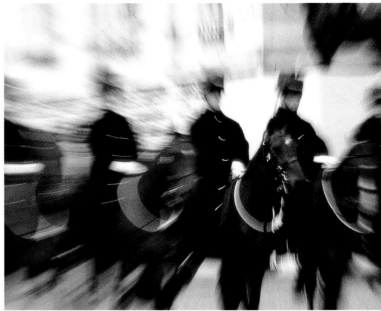

▲

Injecting subject movement into a perfectly stationary subject does require some imagination. You could, for example, set a slow shutter speed and move the camera during the exposure. This technique sometimes produces excellent (but always unreliable) abstract results, especially at night when street lighting, car headlights and colourful store windows streak and smear all over the frame. A more predictable way of achieving the excitement that movement brings to an image is to use the technique illustrated in this example. Selecting an aperture that required a slow shutter speed, the photographer zoomed the lens from the longest to the shortest setting while the shutter was open. Note that the horse in the centre of the frame (directly in front of the lens) appears hardly affected, while horses and riders appear more and more blurred the further away from the lens axis they are positioned.

PHOTOGRAPHER:
Jonathan Hilton
CAMERA:
35mm
LENS:
80–210mm zoom
(zoomed during
exposure)
FILM:
ISO 200
EXPOSURE:
¹⁄₁₅ second at f16
LIGHTING:
Daylight only

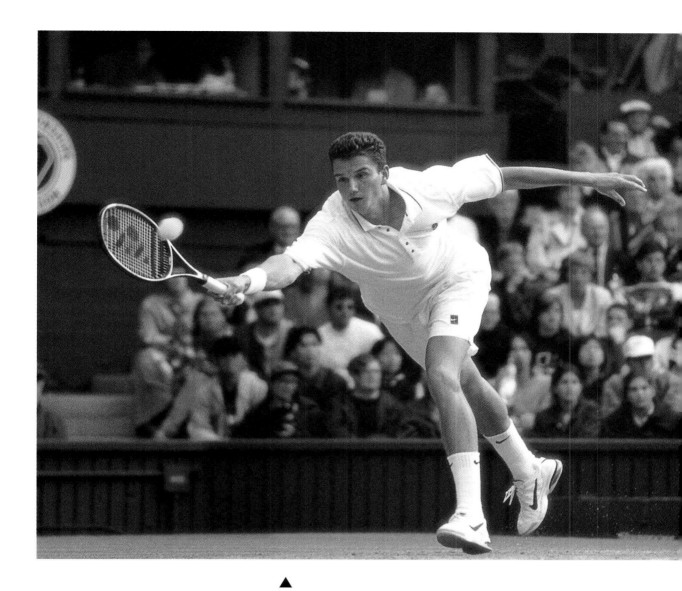

▲

When the action is fast moving and you need a sharp, detailed picture you have no option other than to set a shutter speed that will stop the subject in its tracks. Here, tennis champion Richard Krajicek lunges across the court to reach a speeding ball that is almost out of his reach. Luckily the photographer was shooting in bright sunshine and so he had plenty of exposure options at his disposal and he had the camera's shutter preset at $^1/_{500}$ second. Even at this shutter speed, however, you can see that the ball still looks slightly distorted by movement, but this only adds to the appeal of the shot.

PHOTOGRAPHER:
Popperfoto/Dave Joiner
CAMERA:
35mm
LENS:
210mm
FILM:
ISO 100
EXPOSURE:
$^1/_{500}$ second at f8
LIGHTING:
Daylight only

The intriguing nature of this example of movement relies on the contrast the photographer has created between blurred and sharp detail. Despite the complexity of the image, the photographer's control over all of the elements making up the image has remained firm, which can be seen in the care and attention that has gone into finding just the right setting of towering spires and clock towers. Timing the shot was crucial, however, so that the double-decker bus, seeming to thunder by, acts as the immediate background to the subject without blotting out any of the pictorially crucial parts of the environment.

PHOTOGRAPHER:
Damian Gillie
CAMERA:
6 x 7cm
LENS:
135mm
FILM:
ISO 125
EXPOSURE:
$\frac{1}{30}$ second at f4
LIGHTING:
Daylight and flash

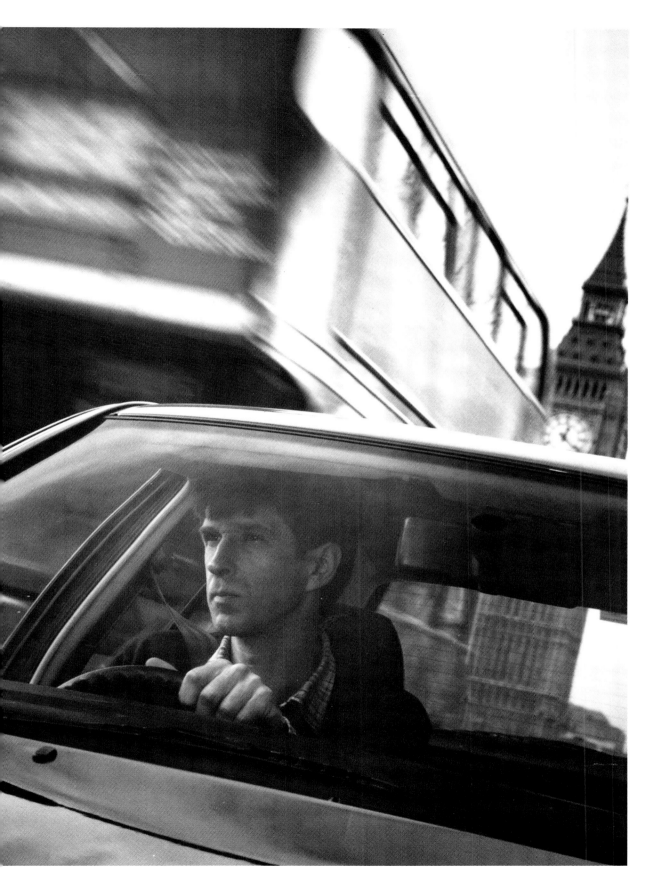

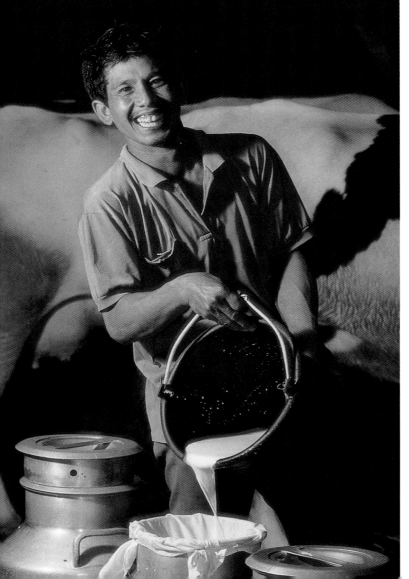

Relating subject and setting

THE SUCCESS OF A PHOTOGRAPH OFTEN DEPENDS as much on what you leave out as what you include, and in order to unify the subject and setting, it is nearly always best to show only that part of the environment that is particularly relevant to your subject or the idea motivating the image. Include too much of the surroundings and you run the risk of weakening the message of your picture, while cropping in too tightly on the subject may make an excellent portrait, but what else does the image then communicate to the viewer? Getting the mix right can be a delicate balancing act, and even the smallest lapse of concentration can upset that equilibrium and turn a potential winner into an also-ran.

Deciding on what to include and what to omit is only part of your task, however. No matter how good the content of a picture, unless all the elements are arranged in an effective and eye-catching fashion the shot will

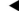

The warm colouration of the late afternoon light was ideal for this shot, which was intended for use in the annual report of a milk marketing organization. Since it was easier to move the photographer's equipment out into the country than bring a cow to the studio, a farm location was researched for the photo session. Because only a hint of rustic surroundings can be seen in the wooden beam behind the cow, it was more important to find a location where the light was reliably good. Even so, two trips were necessary since the first day's shoot was spoiled by overcast light.

PHOTOGRAPHER: **Edward Tigor Siahaan**	FILM: **ISO 100**
CAMERA: **35mm**	EXPOSURE: **$\frac{1}{25}$ second at f8**
LENS: **80–200mm zoom (set at 110mm)**	LIGHTING: **Daylight and studio flash**

not have the required impact. As you can see from some of the pictures on these pages and the ones that follow, the subject (specifically the human element) does not have to take up a large percentage of the frame to have impact – if well positioned, even a small-sized figure will draw attention to itself. Also, look for a camera angle that best presents all the visual information in the most telling way. Pay particular attention to any unfortunate line-of-sight effects (false attachment), for example, since these can make elements in the background appear to be growing out of a foreground feature or subject; or perhaps there is a small, over-intense splash of colour somewhere in the setting that will distract attention from the subject, or it could be that from your shooting angle, the colour and tonal qualities of the subject are too similar to those of the background and so there will be insufficient separation of subject planes. Above all, though, consider the prevailing lighting conditions. Is it of the right intensity? Is it too warm or too cool? Does it create over-intense areas of shadow or over-bright highlights? Is it directional enough to emphasize surface texture? Is it sufficiently frontal to fully describe the subject and environment? These are just some of questions you need to ask yourself before shooting.

The photographs in this topic depend largely for their success on the way the photographer has related subjects and settings, blending these two components so effectively that each adds levels of meaning to the other. But the crucial creative decision, mechanically at least, is the simplest of all: when do you press the shutter release? In all the examples here, the photographer has timed each shot so well that each image, although a static representation, seems to be full of energy and movement.

▲

The off-centre position of the subject of this photograph allows plenty of space for the setting to feature and inextricably links the figure with the church building behind.

PHOTOGRAPHER:	FILM:
Edward Tigor Siahaan	**ISO 100**
CAMERA:	EXPOSURE:
35mm	**½₅₀ second at f8**
LENS:	LIGHTING:
20mm	**Daylight only**

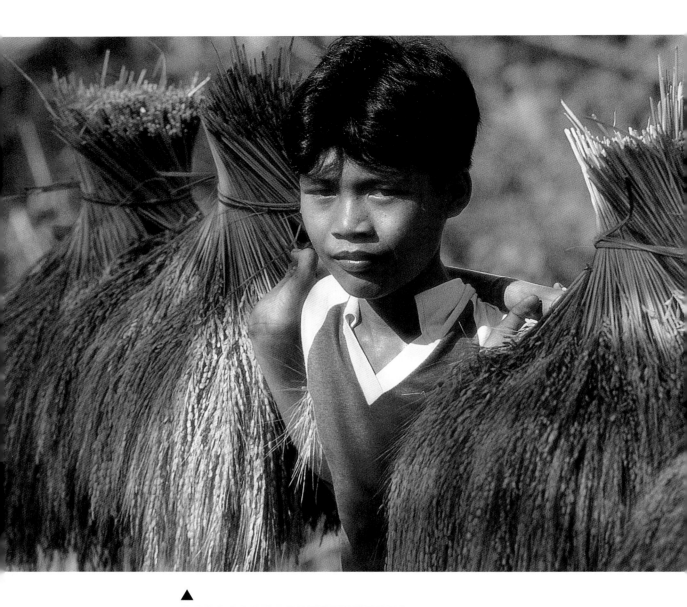

▲

PHOTOGRAPHER:
**Edward Tigor
Siahaan**
CAMERA:
35mm
LENS:
**80–210mm zoom
(set at 210mm)**
FILM:
ISO 100
EXPOSURE:
1⁄500 second at f5.6
LIGHTING:
**Daylight and
studio flash**

Camera angle and focal length were vital
components in the success of this shot.
Using a telephoto setting on his zoom
lens, the photographer has reduced the
background to a green blur, allowing us to
concentrate on the figure and the
attractively shaped bundles of rice plants
he is carrying. The light is bright yet
gentle and the slight dappling helps to
define the subject well. The angle of the
shot has created a strong diagonal line
running through the picture and this helps
to bring life and a strong sense of
movement to the composition.

A splash of sunshine-yellow blooms glows against a dark-green background, grabbing your attention and, initially, holding it in the immediate foreground of the photograph. The dots of yellow of the still closed chrysanthemum blooms pick up on the foreground colour and lead your eye progressively deeper and deeper into the frame.

PHOTOGRAPHER:
Edward Tigor Siahaan

CAMERA:
35mm

LENS:
20mm

FILM:
ISO 100

EXPOSURE:
½₅₀ second at f8

LIGHTING:
Daylight only

The well-integrated subject matter of this photograph, which was taken in a foundry, shows a pile of metal castings in the foreground, dramatic flames leaping from the molten metal behind and a foundry worker in between. Light levels in the foundry were too low by themselves for photography without a very long, manually timed exposure, and so to record the castings and the subject a studio flash fitted with a brollie reflector was used in the foreground. But to capture the atmosphere of the working environment, a relatively slow shutter was needed to allow the flames to make their full impact on the background.

PHOTOGRAPHER:
Edward Tigor Siahaan
CAMERA:
35mm
LENS:
80–200mm zoom (set at 90mm)
FILM:
ISO 100
EXPOSURE:
⅛ second at f5.6
LIGHTING:
Available light and flash x 1 (fitted with a reflective umbrella)

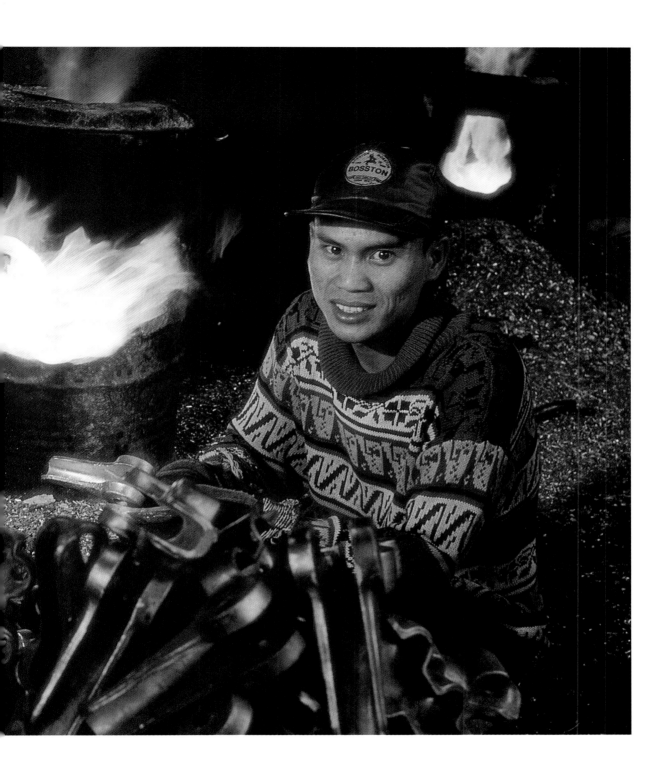

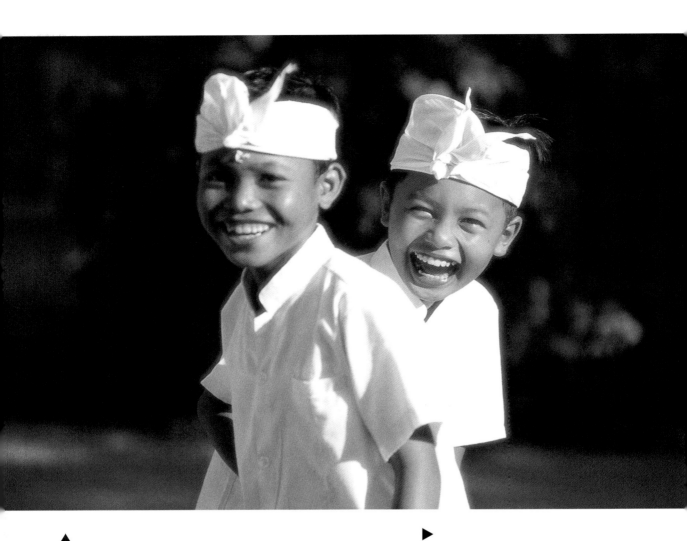

▲

Fully lit, light-clothed subjects allowed the photographer to set an exposure that would record them while showing the background as a contrasting area of shadow relieved by faint, out-of-focus highlights on the road behind.

PHOTOGRAPHER:	(set at 180mm)
Edward Tigor	FILM:
Siahaan	**ISO 100**
CAMERA:	EXPOSURE:
35mm	**½₅₀ second at f4**
LENS:	LIGHTING:
80–200mm zoom	**Daylight only**

▶

This beautifully conceived photograph shows a forestry worker shot from a low camera position with an extreme wide-angle lens. This low angle effectively increases the apparent stature of the subject, but he, in turn, is dwarfed by the forest trees towering behind him. And between the subject's fingers is a tiny seedling, with its first seed leaves just showing, from which the monsters behind are grown.

PHOTOGRAPHER:	FILM:
Edward Tigor	**ISO 100**
Siahaan	EXPOSURE:
CAMERA:	**½₂₅ second at f11**
35mm	LIGHTING:
LENS:	**Daylight only**
20mm	

There is no wrong light for photography – you just need to see how best to take advantage of it. Had the photographer attempted this type of shot at ground level from the same orientation, the shafts of light streaming in through the huge, high windows of New York's Grand Central Station would have flared into the camera lens and overpowered the film's ability to record anything of use. From high up, however, the scene is transformed. Looking like an enormous searchlight beam, the intensity of daylight most directly striking the commuters seems to have nibbled away at their outlines, reducing their legs to sticks and casting formless shadows that are, in some cases, more substantial than the figures themselves. Where the light is less direct, a more normal balance of tones emerges, and sufficient reflected light has bounced around the building's cavernous interior to describe it perfectly and to give sense to the hurrying activity below. To bring the print into line with the photographer's vision of the scene at the time of shooting, she printed the negative on grade 4 paper to minimize the appearance of half-tones.

PHOTOGRAPHER:
Linda Sole
CAMERA:
35mm
LENS:
35mm
FILM:
ISO 400
EXPOSURE:
¹⁄₆₀ second at f8
LIGHTING:
Daylight only

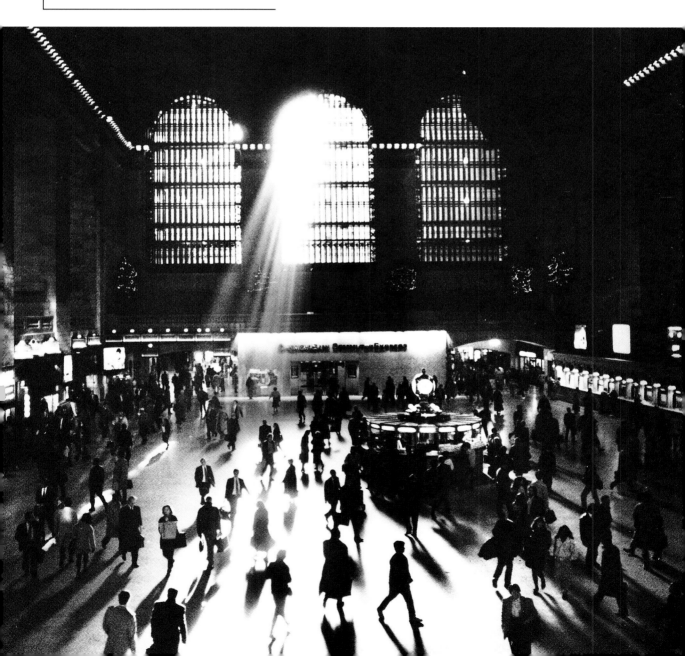

SILHOUETTE LIGHTING

Recording the subject as a silhouette can be an effective way of creating a graphically powerful image. The absence of surface details reduces the subject to its most essential element – that of shape.

- Ensure that the subject is between the camera and the sun, or other principal light source, so that the light is shining in the direction of the camera.
- Take a light reading from the brightest part of the scene and lock that exposure setting into the camera.
- Recompose the shot if necessary so that the subject is positioned properly in the setting before taking the picture.
- To create a total silhouette, the exposure difference between the brightest part of the scene and the side of the subject facing the camera should be at least 3 stops.
- If you want a semi-silhouette, open up the aperture (or reduce the shutter speed) by about 1^1/$_2$ stops.

As your confidence at handling different light effects grows, you may feel tempted to modify the effects of sunlight on your subject. Electronic flash can happily be used in conjunction with sunlight because they both have approximately the same colour temperature, so colour casts should not occur. Accessory flash used out of doors, or in large, open spaces indoors, has little penetration since there will be few, if any, reflective surfaces to contain and return its output, but it can be ideal when all you need to do is modify the lighting on a small, isolated, nearby part of a scene. When contrast is low overall, flash directed at the highlights may add sparkle or drama; when directed into the shadows, it can reduce the exposure differences in a high-contrast scene. Even a simple reflector (a piece of white cardboard, for example), if strategically

▲

Having positioned the subject and set her camera up on a tripod, the photographer taped sheets of heavyweight tracing paper over the window panes, cutting away one section to allow a beam of undiffused light through to the side of the subject. To prevent the back of the room becoming swallowed up in shadow, an accessory flashgun was positioned on the far side of the desk the subject is leaning against. The flash was angled upwards to light the far wall and shelves. A cable ran from the camera, along the floor to the flash, to ensure the flash and shutter fired in synchronization.

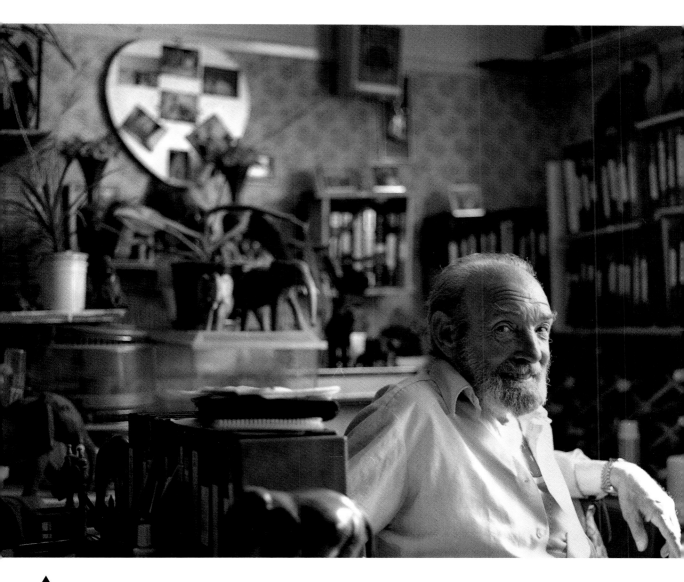

▲

Daylight used indoors can be very contrasty, especially if the sun is directly illuminating the scene and the window area is small. A high-contrast effect may be exactly what you are looking for but, if a softer result is required, try diffusing the light before it reaches the subject. Prior to taking this photograph, the photographer taped sheets of heavyweight tracing paper over the glass panes of the window admitting light to the room. This had the effect of spreading and softening the sunlight, but contrast was then rather dead and not at all satisfactory. The solution was to cut some of the tracing paper away to allow direct light through to the subject's chest and the far side of his face. An accessory flash was also used to light the very back of the room and the subject's collection of wooden elephants. To retain as many of the scene's half-tones as possible, the photographer printed the negative on soft, grade 1 paper.

PHOTOGRAPHER:
Linda Sole
CAMERA:
6 x 6cm
LENS:
120mm
FILM:
ISO 200

EXPOSURE:
⅙₀ second at f4
LIGHTING:
Daylight and accessory flash

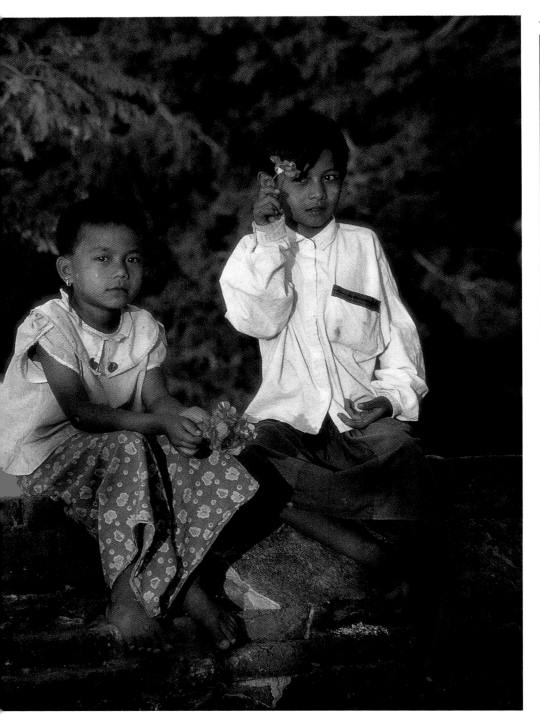

Although the colour temperature of daylight is talked about loosely as if it is constant, in fact the usual designation of about 5000 K (kelvins) applies only to 'average' daylight. This image of two Burmese children was taken by the last rays of the setting sun and it has the characteristic warmth, depth and richness of sunlight at that time of day, and a much lower colour temperature designation – one more akin to tungsten lighting. The setting behind the children is simple and has been rendered out of focus by the use of a large lens aperture, and the contrast between soft background and sharp foreground helps to project the subjects forward in the frame.

PHOTOGRAPHER:	FILM:
Jonathan Hilton	ISO 200
CAMERA:	EXPOSURE:
35mm	$\frac{1}{125}$ second at f5.6
LENS:	LIGHTING:
80–210mm zoom (set at 210mm)	Daylight only

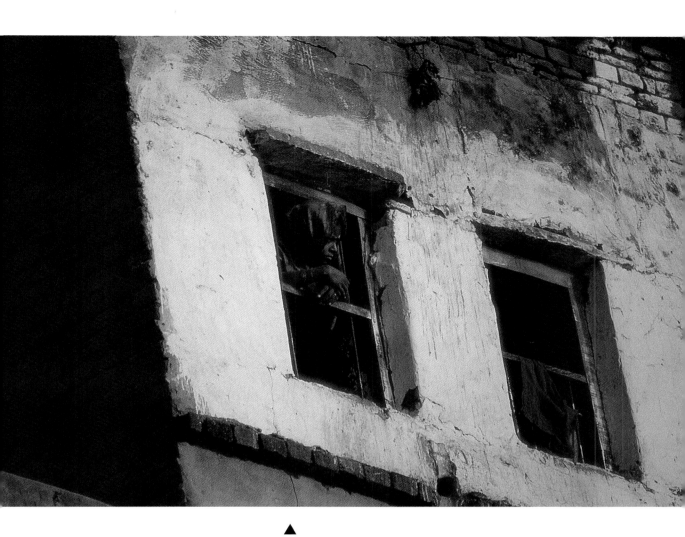

placed, can throw a vital extra f stop of light up into, say, your subject's face, if shadows on that part of the scene are too dense.

In a formal or directed photo session, indoors or out, ask your subjects to move about in relation to the light source while you observe how the light reaching them from various directions brings out different aspects of their appearance – light from the side, for example, can be ideal for emphasizing texture; front- and sidelighting combined may be best for showing a subject's form; while backlighting can be used to suppress all surface detail completely, so all that is left is a silhouette – in other words, pure shape.

▲

The environment is crucial to the success of this candid portrait, which was taken in the cool light just after dawn, before the sun had completely cleared the horizon. The old and stained paintwork, exposed bricks, glassless and dilapidated window frames and crumbling masonry tell us about the social conditions of the subject, while the richness of colour of the sari is an effective contrast to the surroundings. Compare the colour of the daylight in this image with that on the left, which was taken just before dusk.

PHOTOGRAPHER:
Jonathan Hilton
CAMERA:
35mm
LENS:
500mm
FILM:
ISO 200
EXPOSURE:
⅟₆₀ second at f8
LIGHTING:
Daylight only

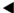

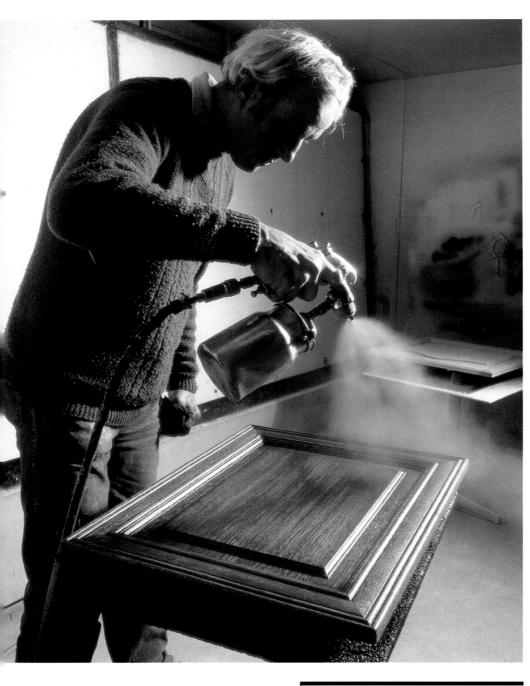

Commissioned corporate photographs are planned with their intended use firmly in mind. For example, this picture was intended to be used small on the page of an advertising brochure and so the simplest of backgrounds was planned – and a simple, yet dramatic, lighting effect was also called for. Anything more complex might have looked muddled and confused when reproduced small on the page. The backlighting has effectively illuminated the subject's face and, just as importantly, the spray varnish being applied to the kitchen cupboard door.

PHOTOGRAPHER:	FILM:
Strat Mastoris	**ISO 100**
CAMERA:	EXPOSURE:
6 x 6cm	**1/30 second at f11**
LENS:	LIGHTING:
80mm	**Studio flash x 1**

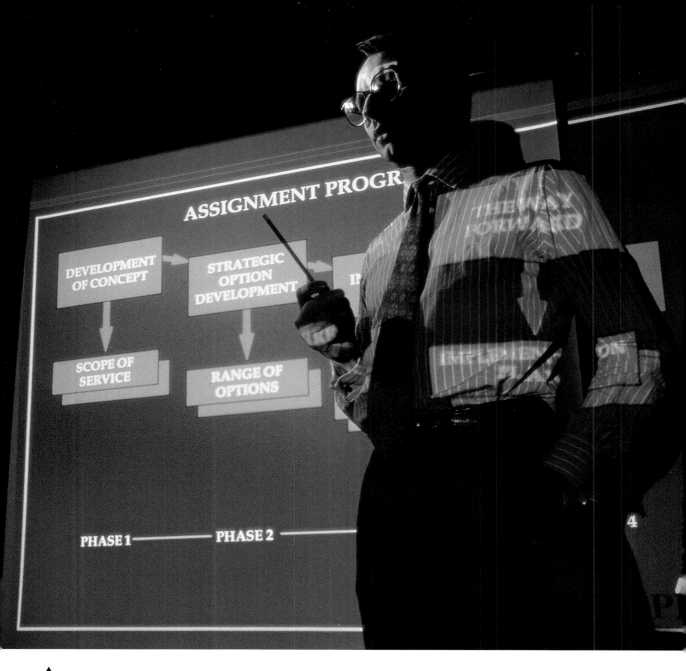

▲

An imaginative way of integrating the environment and the subject through lighting was hit upon by the photographer here. Taken as part of an in-house training manual, it was decided to light the subject with the projected image of one of the training slides, running the image over the subject's body. To achieve the right level of lighting contrast, all room lights had to be turned off, and for that single area of natural-looking illumination on the subject's head, a heavily-snooted flash unit was used.

PHOTOGRAPHER:
Strat Mastoris
CAMERA:
6 x 6cm
LENS:
50mm
FILM:
ISO 100
EXPOSURE:
4 seconds at f11
LIGHTING:
Projected slide image and studio flash (fitted with snoot)

Studio flash and snoot

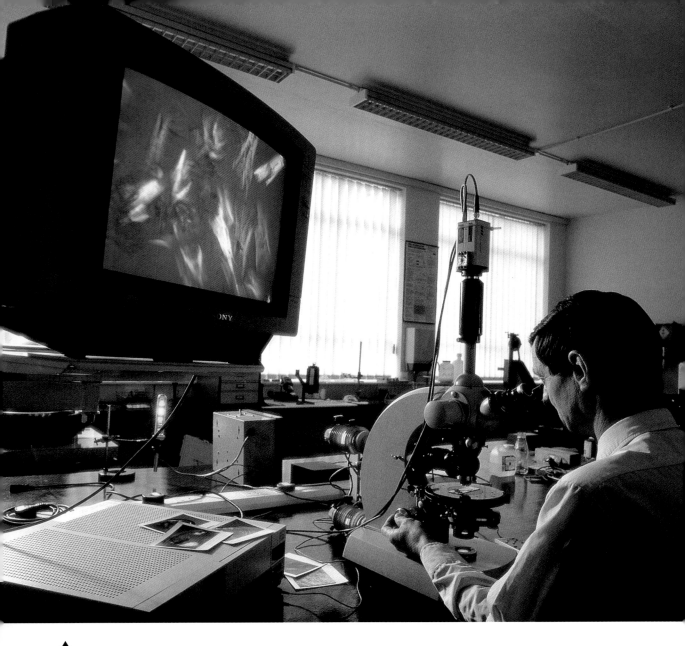

▲

An atmosphere of calm, thorough, analytical study was required for this image, which shows a scientist examining the structure of glass through a polarizing telescope, with the image from the microscope displayed on the monitor above the subject. To achieve this, all room lights were extinguished to increase image contrast on the screen, and a time exposure was used to balance the light output from the screen with the weak daylight filtering in through the windows in the background. A wide-angle lens ensured that depth of field was such that the carefully composed pieces of scientific equipment throughout the room remained recognizable. A single studio flash unit was used to produce the highlight on the table and control box under the elevated monitor.

PHOTOGRAPHER:
Strat Mastoris
CAMERA:
6 x 6cm
LENS:
40mm
FILM:
ISO 100
EXPOSURE:
½ second at f11
LIGHTING:
Daylight and studio flash (fitted with reflective umbrella)

In order to show the rich decoration of the costume and headdress of this young Thai boy, photographed just before his entry into a monastery for his time as a novice monk, the photographer wanted a completely even lighting effect, yet the illumination could not be so bright as to dissipate colour or wash out skin tones. To achieve this end, studio lighting units were used either side of the camera position so that their light reached the subject at about 45°. Each light was fitted with a scrim to prevent glaring reflections from the gold decoration. Careful placement of the flash units ensured that no conflicting shadows occurred, and the boy was positioned far enough in front of the background to ensure that it did not pick up any light spilling past the subject.

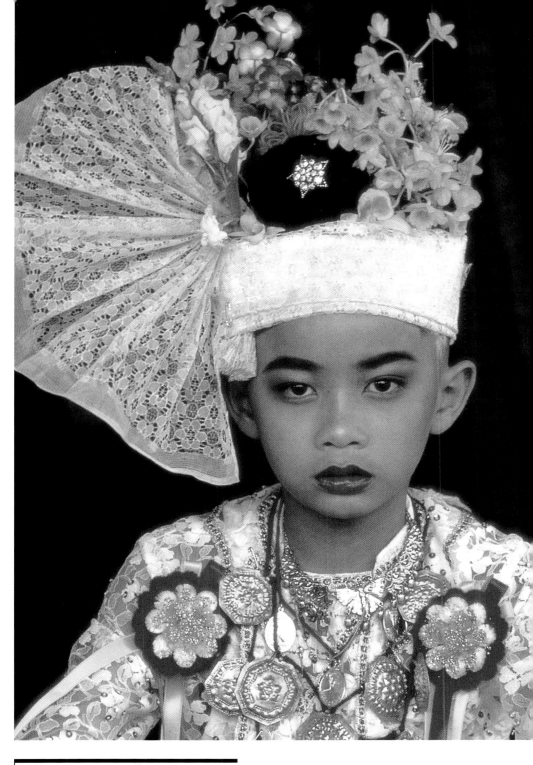

PHOTOGRAPHER:
Gilles Mermet/FSP/ Gamma
CAMERA:
35mm
LENS:
90mm
FILM:
ISO 50

EXPOSURE:
⅟₆₀ second at f22
LIGHTING:
Studio flash x 2 (both fitted with scrims)

2

FORMAL INFORMAL

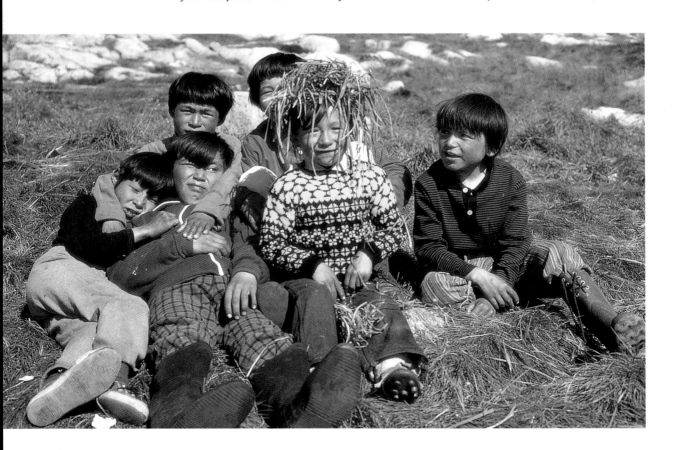

Working with children

I⊤ IS USUALLY FAR EASIER TO PHOTOGRAPH CHILDREN AWAY FROM THE STRANGE, artificial and, for some individuals, rather intimidating environment of the studio. Children will often be more at ease outdoors, perhaps playing together, or even indoors in their own home or in some other place they are familiar with. At a prearranged photo session where you don't know the children concerned, take the time to get to know them a little. They will probably be curious about you, your equipment and how everything works. If they are curious, try to answer all of their questions, but remember to use language that is appropriate to their age and level of understanding. If the environment you have chosen for the session is stimulating enough, they will soon turn their attention to their own activities and let you get on with taking the pictures you want.

Pictures shot outdoors do not, of course, have to be candid in approach. If one of the best reasons for not using a studio is the enormous variety of settings you will then have at you disposal, make sure you select your locations with care and pose your subjects where both they and the environment complement each other,

strengthening the overall impact of the image. Use the lens's aperture control to determine the depth of field for each shot, so that the surroundings have the right degree of blurriness or sharpness. It may be, for example, that selecting the maximum aperture your lens offers is appropriate when you want to reduce a background to an indistinct blur in order to concentrate attention solely on the subject; conversely, selecting the minimum aperture may be a better choice when a sharply-rendered environment is essential to the success of a particular image, and when there is no danger that the subject will become lost in a mass of clearly defined detail.

◄

Living near the arctic circle means you need to rethink your concept of night and day, dark and light, since during the middle of the short summer season the sun never dips down below the horizon. The children take full advantage of this period to cram in as much activity as they can together before the summer ends and the near perpetual darkness forces them to adopt a more constrained, indoor life once more. Although brightly lit, this shot was taken in the early evening and the group of children shown here were flagging. Outsiders in their village are a curiosity, and the children had been following the photographer on and off for many hours hoping that he would take their picture. A soon as the lens was turned in their direction they quickly flopped down into a good-natured, informally arranged group.

PHOTOGRAPHER:	FILM:
Bert Wiklund	**ISO 100**
CAMERA:	EXPOSURE:
35mm	**1/125 second at f8**
LENS:	LIGHTING:
28–80mm zoom (set at 80mm)	**Daylight only**

▲

Confident and self-possessed and wearing jeans, T-shirt and trainers – the very picture of a modern, urban child. And what better place to pose her than in front of an icon of the modern, urban age – a high-rise block of apartments. In order to show the background consisting entirely of the softly focused building it was necessary to raise the little girl up a few feet by standing her on a flat-topped hand rail and then shoot from a low angle looking up at her.

PHOTOGRAPHER:
Damian Gillie
CAMERA:
35mm
LENS:
100mm
FILM:
ISO 125
EXPOSURE:
1/125 second at f2.8
LIGHTING:
Daylight only

GENERAL HINTS

- Before taking any picture, look carefully at the whole of the viewfinder image. Note what effect the background and foreground colours, shapes and tones will have on the subject.
- In most situations, it is best to shoot from approximately the level of a child's eyes. If your subjects are much shorter than you are and you shoot from a standing position, most attention will be drawn to the tops of their heads. Pictures tend to engage the viewer more intensely when they are taken at the subject's eyeline.
- If you are working in black and white, you have to translate the colours around you into the tones they will finally appear as on the print. Bear in mind that some distinctly different colours will reproduce as surprisingly similar tones, while some similar colours will appear as very different tones.
- If you don't want your presence to influence the behaviour of your young subjects, then hang well back from them and shoot with a longer lens.
- At a formal photo session, remember that the attention span of children is often much less than that of adults, so work quickly before your subjects become bored, fractious and uncooperative. If necessary during a long session, take plenty of breaks and try to make most of the time the children spend in front of the camera into some sort of game.
- Always keep alert to the changing moods of your subjects. With children, it is not uncommon for tears to turn to laughter in a matter of seconds.

▶

Sometimes the environment just seems to get on top of you! After scraping a depression in the pebbles, one of a group of children fitted himself into it while the others covered him right up to his neck. Waiting until the children had finished, the photographer asked if he could take the victim's picture, which he couldn't do anything to prevent but happily agreed to anyway. Moving in close with a wide-angle lens and lying flat on the beach, the effect has been to exaggerate the size of the boy's head in relation to the much smaller distant figures strolling by at the water's edge, thus adding another level of humour to an already funny situation.

PHOTOGRAPHER:
Bert Wiklund
CAMERA:
6 x 6cm
LENS:
45mm
FILM:
ISO 100
EXPOSURE:
1/60 second at f4
LIGHTING:
Daylight only

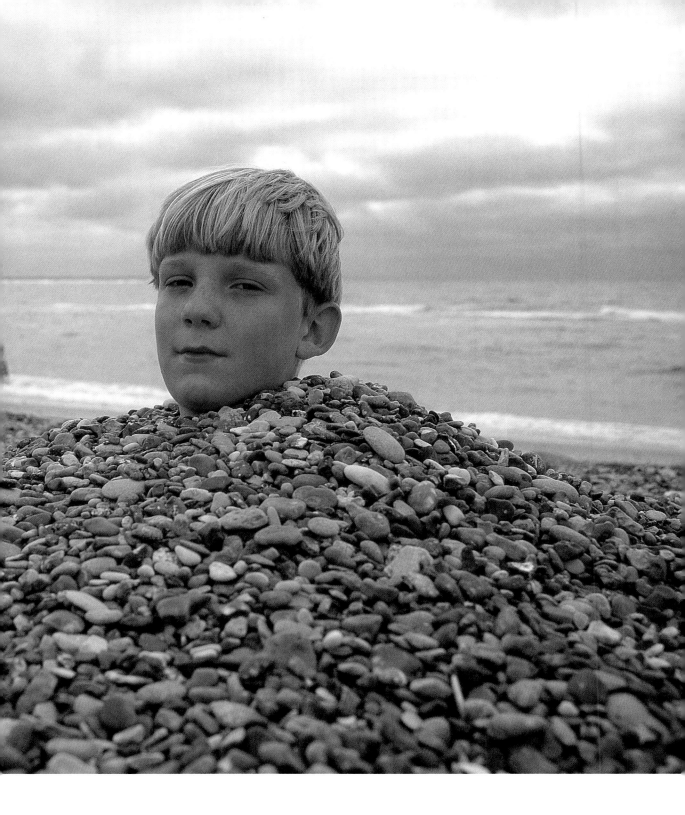

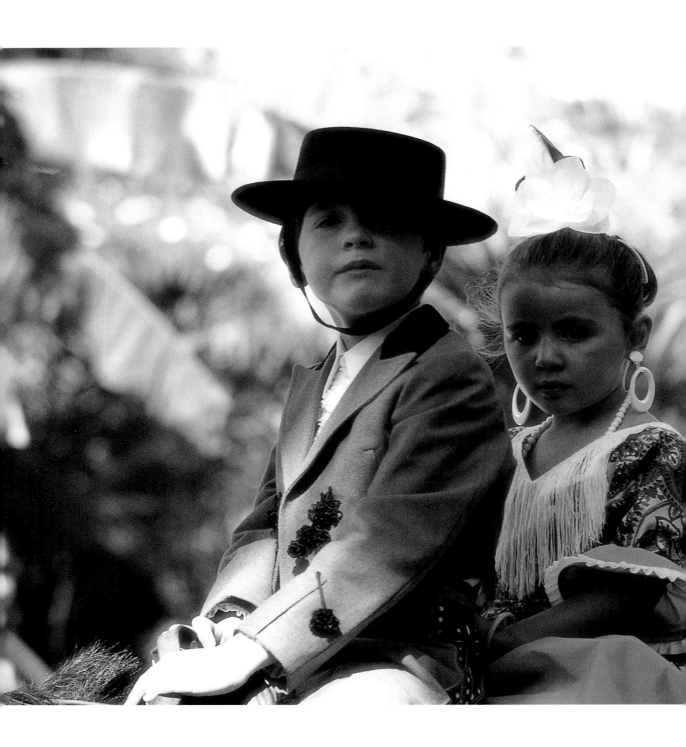

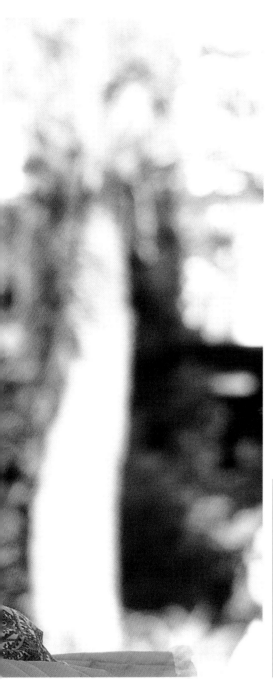

At a prearranged photo session, the parents wanted their children to appear in typical Spanish national costume for some of the shots – and the obvious place to pose them was astride one of the horses on their ranch. When the sunlight is intense, as it was on this day, try to find some shade in which to pose your subjects. This will help to retain the integrity of the colours, which can appear as pale and rather bleached hues in over-bright light, and being out of direct light will also prevent the subjects squinting. It is sufficient to see the brightness of the day as a soft glow in the background of this image.

PHOTOGRAPHER:
Bert Wiklund
CAMERA:
35mm
LENS:
80–210mm zoom
(set at 150mm)
FILM:
ISO 100
EXPOSURE:
$\frac{1}{250}$ second at f5.6
LIGHTING:
Daylight only

▲

By framing this shot to include the edge of the table tennis table, the tiny size of the enthusiastic player has been emphasized. Since she was completely absorbed in the game, the photographer could take his time waiting for all the elements of the shot to come together before squeezing off this picture. The spot-metering facility of the camera used coped easily with the strong backlighting. A general light reading of this scene would have taken too much account of the light flooding in through the background windows and would almost certainly have underexposed the subject.

PHOTOGRAPHER:
Damian Gillie
CAMERA:
35mm
LENS:
100mm
FILM:
ISO 125
EXPOSURE:
⅟₁₂₅ second at f2.8
LIGHTING:
Daylight only

POLARIZING FILTERS

These filters consist of two pieces of polarizing glass mounted together – one is fixed and the other is moveable. While looking through the camera's viewfinder, turn the front, moveable part of the filter until you see the strongest effect on colours or reflections. If you are using a rangefinder or direct-vision camera, you do not see the scene as it is transmitted by the lens. In this situation, hold the filter up to your eye, adjust it until the effect is strongest, and then place the filter over the camera lens while making sure you do not change its orientation. There is always some light loss with a polarizer filter. Autoexposure cameras will adjust themselves to allow for this, but refer to the filter factor printed on the filter mount to make a manual exposure adjustment for the light loss.

▶

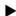

When children have their own activities to get on with, they will most often simply forget that you and your camera are there. To take this shot, the photographer simply had to bide his time until both of the boys in their row boat were fully engaged with their fishing rods and lines. The perspective of the shot and the extensive depth of field indicate that a wide-angle lens was used, and the strength of the blue of the sky and calm lake surface was intensified by the use of a polarizing filter. The filter has strengthened the contrast between the blue of the sky and the white of the clouds and has removed many of the reflections in the water.

PHOTOGRAPHER:
Bert Wiklund
CAMERA:
35mm
LENS:
28mm
FILM:
ISO 100

EXPOSURE:
⅟₂₅₀ seconds at f11
LIGHTING:
Daylight only

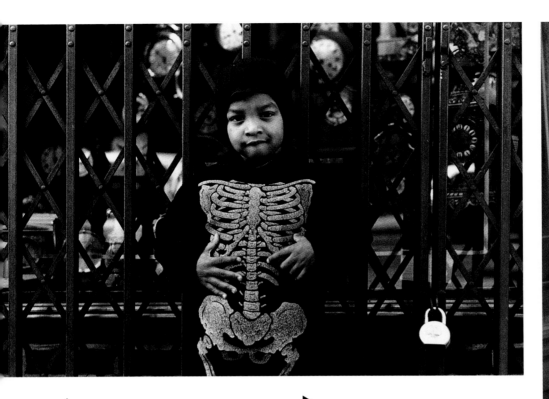

Children love dressing up, and there are costumes galore to photograph at Hallowe'en, when children turn into ghosts, goblins and monsters of all descriptions. The bare bones on the suit of this child have been set off to perfection by the skeletal shape of the security grille of the watchmaker's shop behind.

PHOTOGRAPHER:
Linda Sole
CAMERA:
35mm
LENS:
100mm
FILM:
ISO 400
EXPOSURE:
⅛₂₅ second at f5.6
LIGHTING:
Daylight only

The advantage of carrying a camera with you wherever you go means that a chance opportunity, such as the scene here taken in a near deserted restaurant, can be snapped up. While passing through the dining room, the photographer noticed this lone boy sitting at the far end of a sparsely laid table staring intently out of the window looking for the rest of his family to arrive. With only seconds to shoot off a frame, the photographer quickly took a light reading from the shadow side of the boy, recomposed and released the shutter. Because the picture was taken from a standing position, you can see that the boy's apparent size has been diminished, which is the effect that was wanted in this particular example, since it has created a slight sense of anxiety and increased the sense of the boy's isolation at the table.

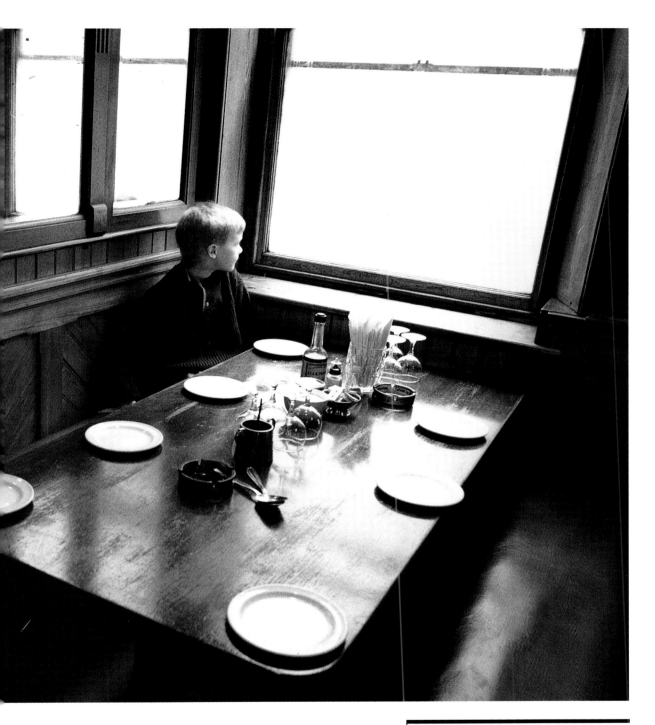

PHOTOGRAPHER:	FILM:
Damian Gillie	**ISO 400**
CAMERA:	EXPOSURE:
6 x 7cm	**⅕ second at f8**
LENS:	LIGHTING:
45mm	**Daylight only**

Seasonal atmosphere

EVEN THOSE LANDSCAPES AND SETTINGS that are most immediately at your disposal are not static or unchanging – a hillside, field or wood – even your local municipal park – can look radically different depending on the season you choose to shoot in.

Spring, for example, brings with it the first early colour of the year, especially where hardy bulbs push their buds into flower before high-level foliage becomes too dense to prevent sunlight reaching the ground. In summer, a riot of sometimes strident colours found in cultivated beds in parks and gardens may look eye-catching and attractive, but can be difficult to handle as a background to a photograph in which, perhaps, you want a more restrained approach. Autumn has its own charms, with its swelling hips, ripening seed heads and the carpeting browns, russets and golds of fallen leaves.

Any investment of time you make into investigating the photographic potential in your local environment will almost certainly pay dividends in terms of additional commissions and repeat business. And bear in mind that the restricted view of the camera means that a seemingly unsuitable setting may be perfect if you use just one small part of it.

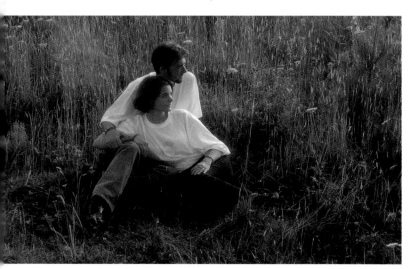

◄

Even when the general setting is not ideal for photography, a carefully selected camera position and a lens with the appropriate angle of view may be able to salvage the situation. In this early autumn double portrait, the swelling heads of ripening grass seed and stems turned golden by the summer's sun has the appearance of a country meadow. In fact, just out of view of the camera were a series of rough paths and flattened areas of stems indicating the more urban environment it really was. In a situation such as this, even if there had been a carpark at the top of the frame or a line of wooden fences defining the backs of nearby gardens, it would not have mattered if they had not been encompassed by the lens.

PHOTOGRAPHER:	FILM:
Llewellyn Robins	**ISO 100**
CAMERA:	EXPOSURE:
35mm	**$\frac{1}{125}$ second at f8**
LENS:	LIGHTING:
55mm	**Daylight only**

A carpet of bluebell flowers is the main feature of the setting selected for this portrait of a young girl. Tree foliage had started to appear but it was not yet dense enough to restrict the light at the base of the tree where the subject was positioned. However, natural light levels were not high on the day of the shoot because of broken cloud cover, so the available daylight was supplemented with reflected flash positioned to the left of the camera.

PHOTOGRAPHER:
Llewellyn Robins
CAMERA:
35mm
LENS:
90mm
FILM:
ISO 100
EXPOSURE:
⅟₆₀ second at f8
LIGHTING:
Daylight and studio flash x 1 (fitted with a reflective umbrella)

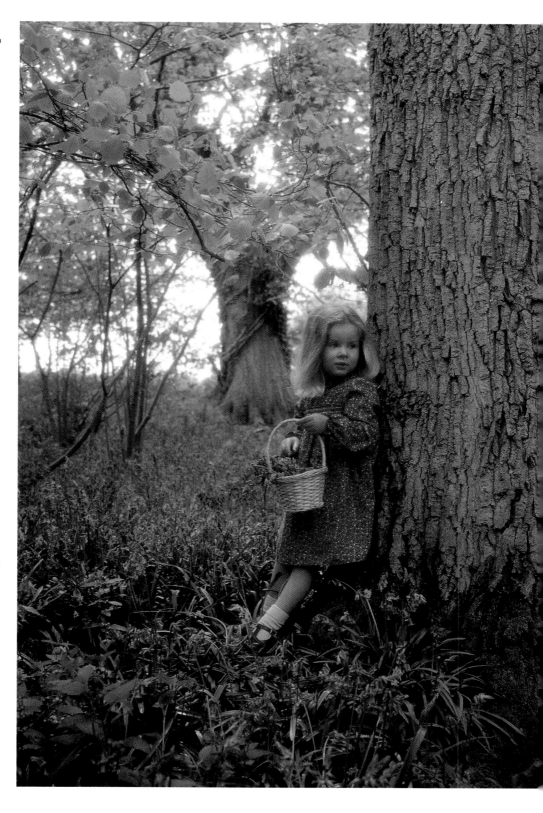

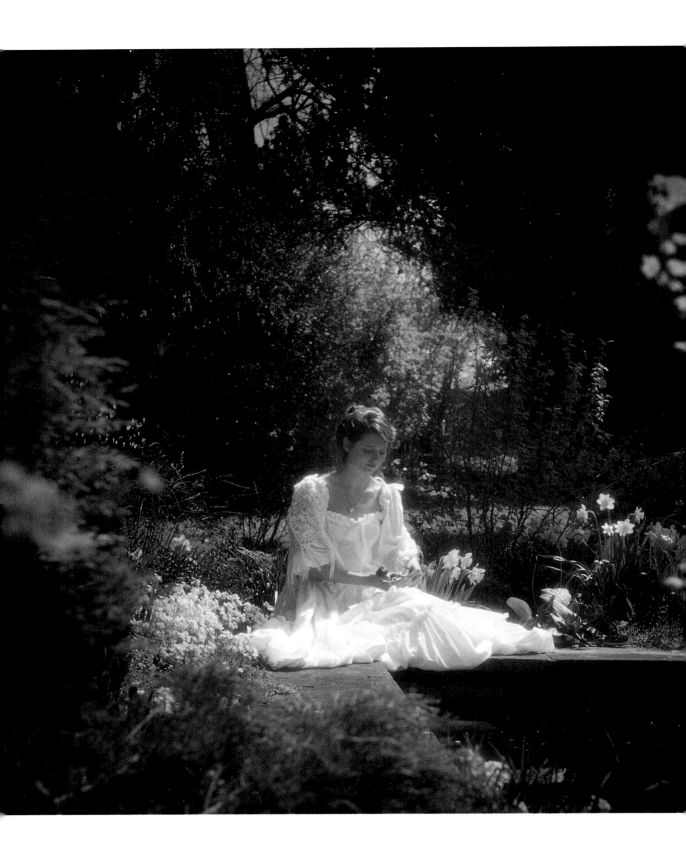

This sun-filled dell was situated in a quiet corner of a garden attached to a private home. Enough spring foliage was present to obscure the broader view that would have revealed its actual location, giving the setting a secluded, secretive atmosphere. The time of year was obviously vital, since the spring daffodils contribute so much to the overall atmosphere of the picture. To complete the scene, however, the photographer placed pots of additional spring flowers among those already growing there, making sure that the plastic pots themselves were obscured either by the subject herself or by plant foliage.

PHOTOGRAPHER:
Llewellyn Robins
CAMERA:
35mm
LENS:
90mm
FILM:
ISO 100
EXPOSURE:
$\frac{1}{125}$ second at f5.6
LIGHTING:
Daylight only

Exploring the setting

PHOTOGRAPHER:
Efren V. Evidor
CAMERA:
6 x 4.5cm
LENS:
120mm
FILM:
ISO 100
EXPOSURE:
¹⁄₁₂₅ second at f8
LIGHTING:
Daylight only

SOMETIMES JUST THE SMALLEST OF ADJUSTMENTS to your camera position or lens focal length can turn an unpromising setting into one perfect for your needs. There may be, for example, some intrusive feature in the middle ground or background, and simply by increasing your shooting height, so that you are looking more downward on the subject, you could restrict the amount of the scene encompassed by the lens and so exclude the problem area. Lowering your shooting position may show your subject against a background of high foliage or the sky, both of which could better suit your purposes. Moving your shooting position slightly left or right could change the entire relationship of elements in the foreground, middle ground and background and so alter the mood and atmosphere of the shot. Always remember, however, to judge changes by looking through the camera's viewfinder, not with your unaided eyes – the effect will be entirely different when an area of the scene is confined within the straight, well-defined edges of the focusing screen.

Not only do the physical characteristics of the setting change when you move camera position or change focal length, so, too, do the angle and quality of lighting

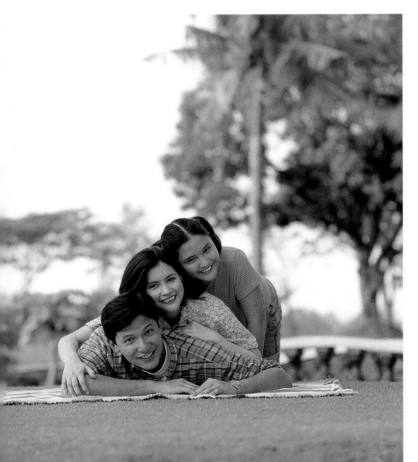

These two photographs were taken for an international banking corporation for use in a brochure targeted specifically at young families. In the first image (left) the photographer has adopted a low camera angle in order to show the subjects against a plain background of sky. However, the trunk of the palm tree seems to be growing out of the back of the young girl (this is called 'false attachment' and is a line-of-sight effect you need to guard against) and the balustrade to one side of the group is also distracting. A stronger image was recorded just by moving the subjects a few feet away from their original position (right). A longer lens has tightened up the framing and the scene has now been propped with a picnic basket. Likewise, the 'zigzag' of head positions in this shot is stronger than the 'stacked' effect in the first.

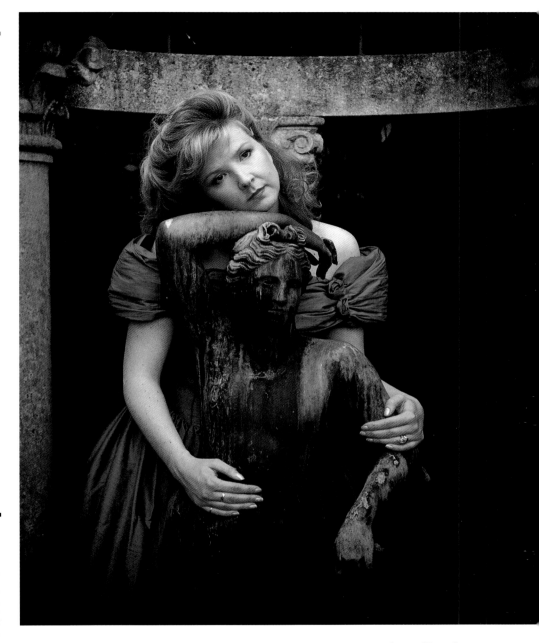

Using the same setting as the previous shot, the photographer has moved closer to the subject and changed to a longer lens to confine the setting and create a more intimate effect. By talking to the subject throughout the session and explaining what he wanted he to do, how to hold her head, and the expression she should adopt, this obviously studied portrait has, nevertheless, a very relaxed and natural quality clients would appreciate.

PHOTOGRAPHER:
Llewellyn Robins
CAMERA:
6 x 4.5cm
LENS:
120mm
FILM:
ISO 100
EXPOSURE:
¹⁄₆₀ second at f11
LIGHTING:
Daylight and studio flash x 2 (both fitted with barn doors)

turning it as black as night and causing white clouds to stand out starkly. For a more subtle effect, a yellow filter will help to define the textural qualities of clouds. To lighten green foliage, use a green-coloured filter. In colour, a useful filter is a polarizer, which with some type of lighting will deepen the colour of blue sky and remove reflections from water or glass window panes. You can also sometimes make better use of the

setting by adding a starburst filter if you have the right type of lighting. Coloured filters will, of course, cause casts with colour film (slide or print film), but if you are confronted with a pale and featureless sky, why not use a half-coloured filter orientated so it affects only the sky part of the frame? You could add a naturalistic colour or opt for an impossibly bizarre effect.

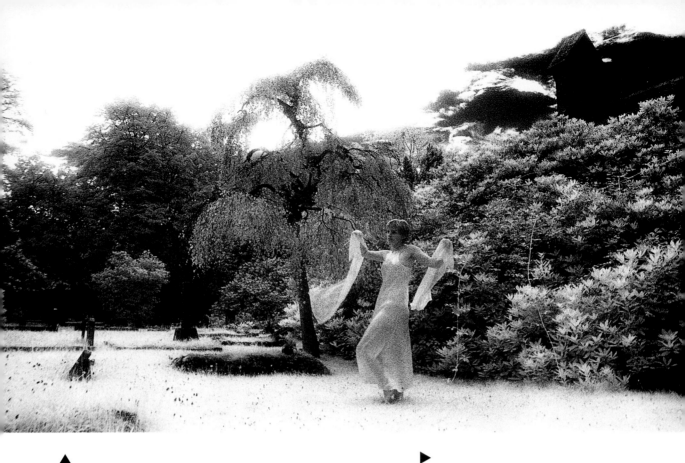

The attractive early summer of this garden environment has taken on a pale, almost dreamlike quality because it was taken on infrared film stock. This material is most sensitive to light in the invisible infrared part of the electromagnetic spectrum, and the tones of the image are determined by how much of that type of radiation different parts of the scene reflect. As you can see, the grass and tree foliage reflect infrared most strongly and so they have been recorded with the palest tones. Because infrared film is also sensitive to ordinary light, the photographer used a deep red filter over the lens to exclude most of the visible spectrum. Infrared film can be rated at a range of speeds, and because of the strong sunlight the photographer set the film speed control for ISO 250.

PHOTOGRAPHER:
Llewellyn Robins
CAMERA:
35mm
LENS:
28–70mm zoom (set at 35mm) (plus deep red filter)
FILM:
ISO 250 (nominal)
EXPOSURE:
⅟₆₀ second at f5.6
LIGHTING:
Natural infrared light

If it were not for the very pale tones of the subject and the unnatural contrast between the tones of the sky and clouds, you would not know that this shot was taken on infrared film. This is because most of the image area is taken up by the walls of a castle, which reflects virtually no light from the infrared part of the spectrum. This type of film requires special handling and must be kept refrigerated. Some professional film stock is kept refrigerated (never in the freezer) anyway to assure complete colour accuracy. Keep it in a sealed plastic bag containing a sachet of silica to prevent condensation and moisture affecting the emulsion.

PHOTOGRAPHER:
Llewellyn Robins
CAMERA:
35mm
LENS:
28–70mm zoom (set at 28mm) (plus deep red filter)
FILM:
ISO 250 (nominal)
EXPOSURE:
⅟₆₀ second at f5.6
LIGHTING:
Natural infrared light

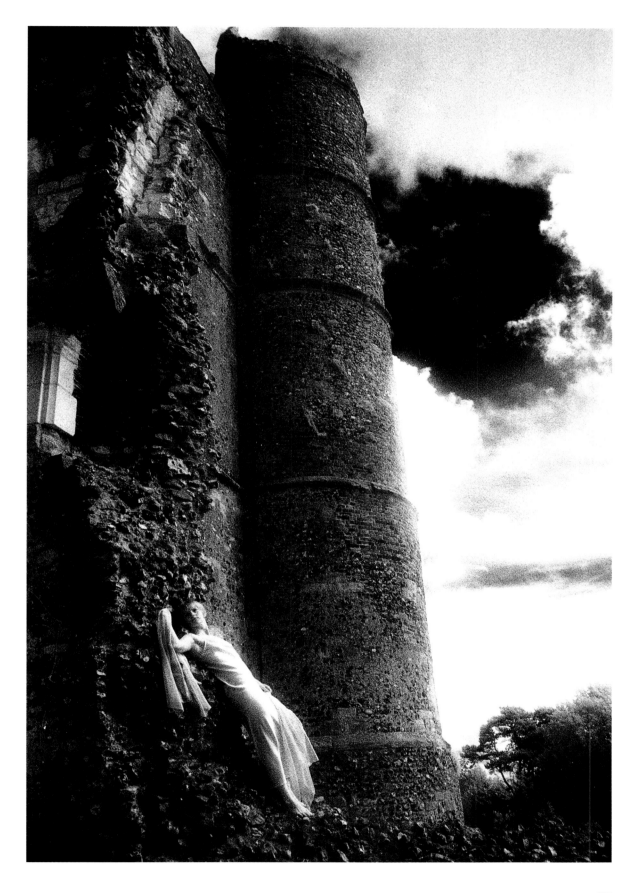

▶

The success of an image is often dependent on the photographer being completely familiar with the equipment and the characteristics of the film being used. In this example, the photographer knew that the combination of infrared film and a deep red filter would turn the blue areas of the sky nearly black, and so he positioned his subject carefully between the clouds, where her pale tones would contrast starkly with it. To confirm the final position before shooting, he checked the scene through the camera's viewfinder from the shooting position. Bear in mind that infrared light does not come into focus at the same point as light from the visible part of the spectrum, and so many lenses have an infrared focusing mark to allow you to make the necessary adjustment.

PHOTOGRAPHER:
Llewellyn Robins
CAMERA:
35mm
LENS:
28–70mm zoom (set at 28mm) (plus deep red filter)
FILM:
ISO 250 (nominal)
EXPOSURE:
⅟₆₀ second at f5.6
LIGHTING:
Natural infrared light

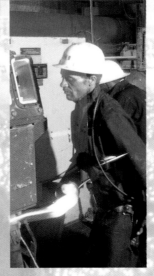

3 WORK AND PLAY

In the workplace

ONE OF THE MAIN ADVANTAGES PHOTOGRAPHERS find in moving out of the rather predictable, often soulless, surroundings of the studio is the huge variety of environments in which they can then depict their subjects. All too often in a formal studio photographic session, the subjects' discomfiture at being in an alien environment leads to unsatisfactory, wooden-looking results, despite the best efforts of the photographer to get them to unwind, relax and enjoy the experience.

It is the aim of most portrait photographers to capture in their work some revealing expression or gesture that communicates something of that person's character and personality to the viewer of the picture. Another level of insight into the character of your subjects can come from photographing them where they feel most at ease and relaxed and where the setting or general environment adds to our overall understanding of the people depicted. Moving the photo session into the home may be the answer, but bear in mind that even the process of setting up your photographic equipment in subjects' homes can turn them to stone. If the home environment proves not to be the answer, then consider the workplace as a setting. This can prove particularly satisfactory when subjects feel that they can express something of themselves through being seen at work, or it could simply be that being in their work environment distracts them enough so that they can concentrate on something else other than feeling ill at ease in front of the camera.

SHOOTING ON LOCATION

A degree of preplanning is necessary when you are working away from the studio on location. You don't want to find your options restricted because you have, for example, forgotten to throw a spare extension lead into the back of the car and so can't position your lights precisely where you want them. Not having the appropriate filters could also cause you grief as could forgetting to include a particular lens in your camera bag.

- If possible, visit the location at some stage before the session to look at the general layout of the area you will be working in.
- Try to visit at the same time of day as the proposed session so that you can see where the sun is in relation to any windows or skylights. With this information, decide if there is likely to be sufficient natural light for your needs or whether you will need supplementary lighting.
- If necessary, rearrange the time of the session to take advantage of more favourable natural light.
- If you will be using supplementary lighting (apart from accessory flash) note where power points are located and bring sufficient extension leads.
- Pack more film than you are sure you will need. An extra two or three rolls gives you that added flexibility to carry on shooting if the session is going particularly well.
- If your camera and flash batteries are not fresh and fully charged, take spare sets with you. Many modern electronic cameras will not function at all if battery power falls below a certain level.
- Think hard about the way you approach a photographic session and take with you any accessories, such as filters, blower brush, gaffer tape, and so on, that you tend habitually to use.

►

Working in black and white frees you from worries about the colour temperatures of any light sources present. As you can see in this diagram, the subject is partially lit by window light from high windows in the wall opposite the subject's face and large overhead lights directly above the printing press. In order to prevent the back of the room being swallowed up in shadow, a tungsten-halogen floodlight was positioned low down, hidden from the camera behind the bulk of the press. A little of this light has spilled on to the subject's forehead, which helps to relieve the shadow cast by the overhead room lighting.

►

The gregarious nature and strong face of the subject of these pictures would have made him the perfect subject for a studio portrait session. But one of the key aspects of the person the photographer wanted to record was his skill as a platemaker and printer, and this meant showing him in his working environment. Shooting in black and white meant that colour casts from room lighting were not an issue, and these shots are illuminated by a mixture of natural window light, domestic tungsten room lighting and tungsten-halogen photographic lighting.

PHOTOGRAPHER:
Linda Sole
CAMERA:
35mm
LENS:
28mm
FILM:
ISO 400

EXPOSURE:
¹⁄₂₅ second at f8
LIGHTING:
Daylight, available room light and tungsten-halogen floodlight

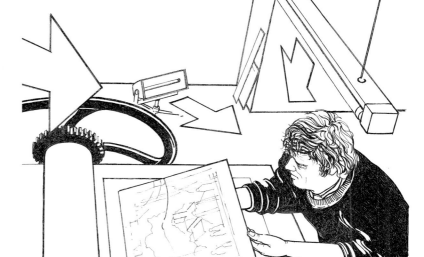

◄

A change of camera position, to a more overhead view, was necessary here to show the paper being peeled away from the plate as the first proof sheet was produced. Although the subject has been marginalized by this camera angle, the shadowy side of his face and his fully lit hand are still important components of the composition. Note, too, how this angle makes the best photographic use of the shapes and forms of the wheels, gears and rollers of the press itself.

PHOTOGRAPHER:	EXPOSURE:
Linda Sole	**⅛₀ second at f8**
CAMERA:	LIGHTING:
35mm	**Daylight, available**
LENS:	**room light and**
28mm	**tungsten-halogen**
FILM:	**floodlight**
ISO 400	

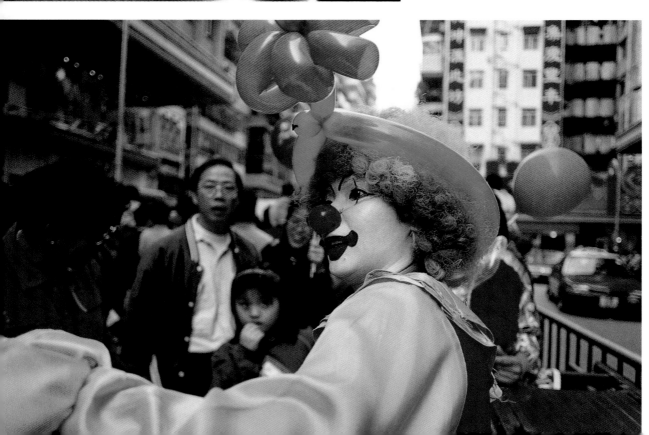

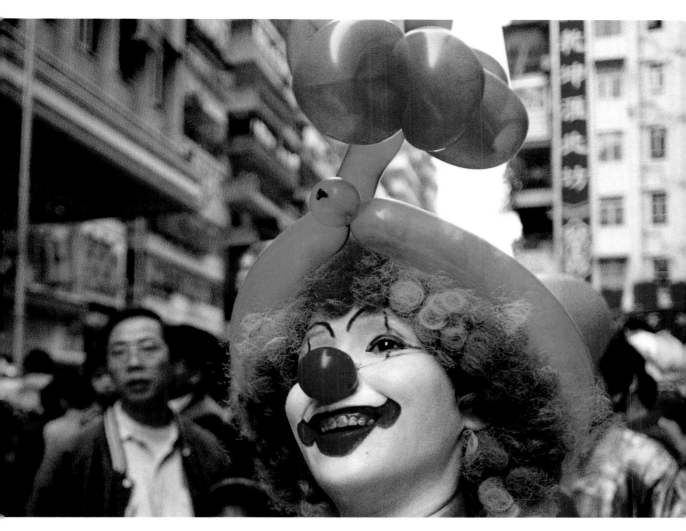

The workplace could be a printer's studio or indeed the public street if, that is, your subject is a street performer. Anybody prepared to dress up in a clown's costume to advertise the opening of a new fast-food outlet is unlikely to be concerned about the attentions of a passing photographer, and this proved to be the case in the busy streets of Hong Kong. The photographer decided to hang back a little and use a moderate telephoto setting on her zoom lens, so the clown was not aware of her until the flash fired (left). In the next shot (above) the slight tilt of the clown's face shows that he is now playing direct to the camera. The effect of using a telephoto setting is twofold here. First, it helps to pull in the passers-by and surrounding road and buildings, making the environment a more important part of the composition than it would have been with, say, a wide-angle lens. Second, the limited depth of field associated with telephoto lenses helps to knock the surroundings back a little by showing them slightly out of focus but still recognizable.

PHOTOGRAPHER:
Linda Sole
CAMERA:
35mm
LENS:
**80–210mm zoom
(set at 90mm)**
FILM:
ISO 100
EXPOSURE:
$\frac{1}{125}$ second at f5.6
LIGHTING:
**Daylight and
accessory flash**

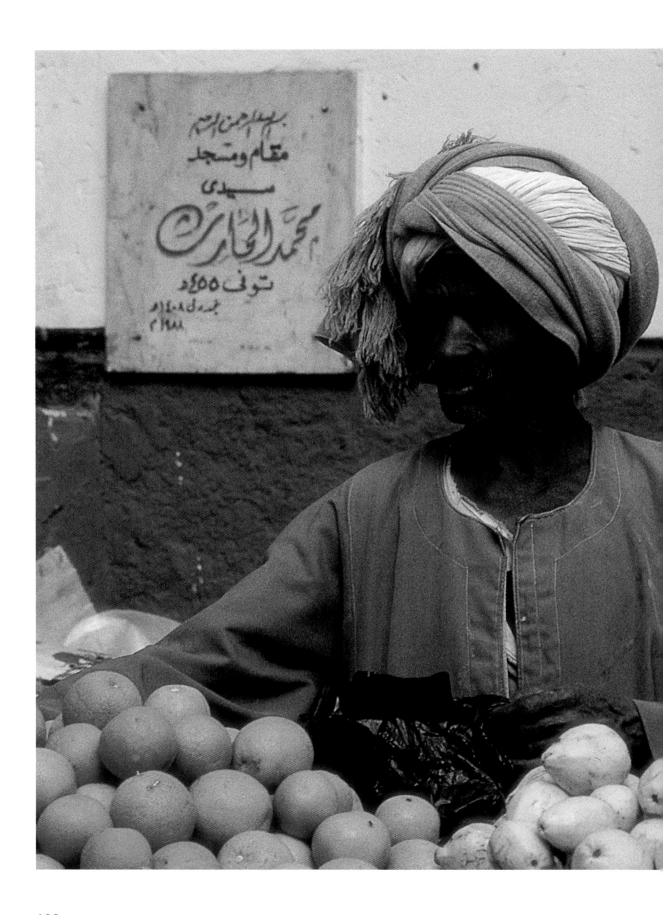

By excluding all irrelevant parts of what
was a busy market environment, what has
been encompassed by the lens creates a
powerful composition of geometric blocks
of colour in the wall behind the subject
that contrast with the more rounded forms
of the figure and the shapes of the heaped
display of pears and oranges forming the
bottom edge of the frame. Dropping the
camera angle down just slightly below a
normal standing height has caused more
of the man's turbaned head to be seen to
better effect against the lighter block of
colour behind him.

PHOTOGRAPHER:
Jonathan Hilton
CAMERA:
35mm
LENS:
**80–210mm zoom
(set at 210mm)**
FILM:
ISO 200
EXPOSURE:
⅟₆₀ second at f11
LIGHTING:
Daylight only

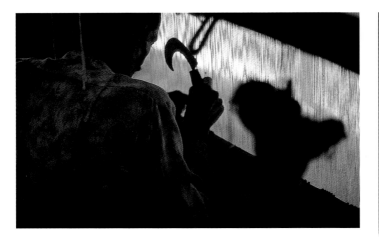

▲

This framing, using a telephoto zoom setting from the point of closest focus, makes superb use of the picture area. The figure, seen as a semi-silhouette, seems to be confined by the carpet he is in the process of weaving – as if his entire environment has shrunk to the few square feet we see him in. Recorded sharply against the light filtering through the woollen strands, the man's carpet hook makes a powerfully graphic shape.

PHOTOGRAPHER:
Jonathan Hilton
CAMERA:
35mm
LENS:
28–80mm zoom (set at 75mm)
FILM:
ISO 200
EXPOSURE:
1/60 second at f4
LIGHTING:
Daylight only

▶

Working with a wide-angle lens close to the sparks flying in all directions from a welder's torch requires protective clothing and some form of protection for your camera and lens to prevent possible damage. The effort is more than justified, however, when you achieve results such as this dramatic workplace portrait. The flare from the molten tip of the torch gave off enough light for the picture, but the photographer set his camera up on a tripod and selected a slow enough shutter speed to produce the light trails from the sparks.

PHOTOGRAPHER:
Damian Gillie
CAMERA:
6 x 7cm
LENS:
45mm
FILM:
ISO 400
EXPOSURE:
1/8 second at f11
LIGHTING:
Mixed available light

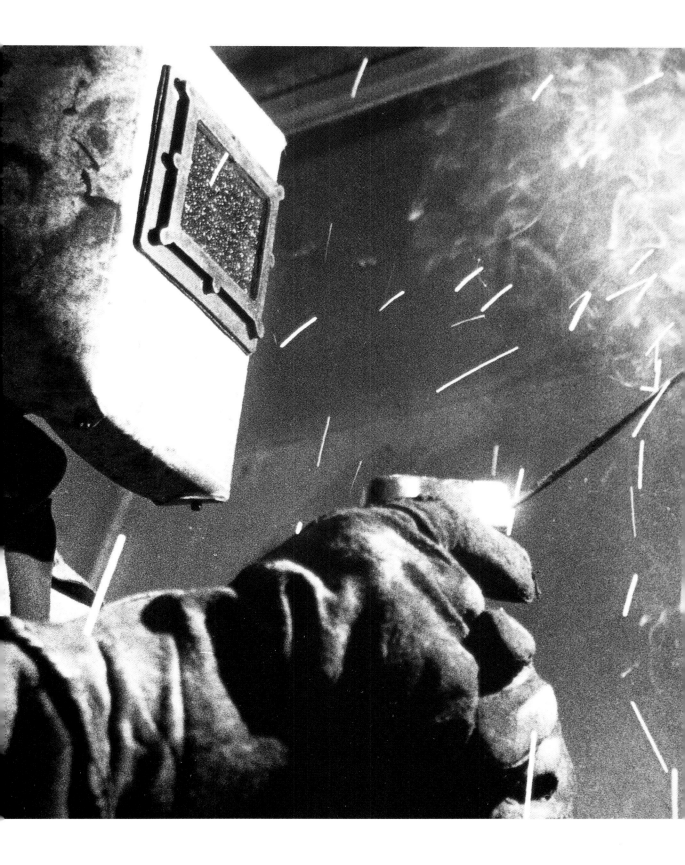

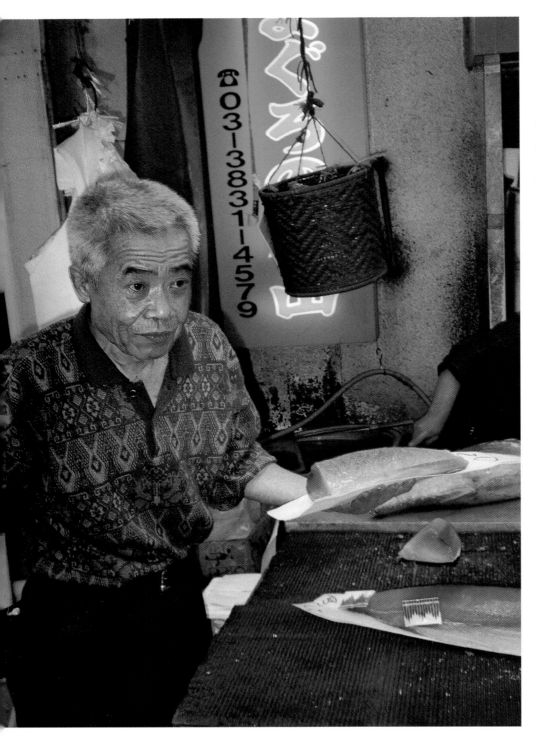

Catching people at work in candid shots is relatively easy if you wait until they are distracted by the demands of their jobs and are not paying much attention to anything else. In this busy Japanese market scene the photographer was using accessory flash mounted on a side bar, since top-mounted flash often results in red-eye. The pop-up viewing screen sun shade found on many types of medium format camera also makes top-mounted flash impossible to use.

PHOTOGRAPHER:
Frits Jansma
CAMERA:
6 x 4.5cm
LENS:
120mm
FILM:
ISO 100
EXPOSURE:
⅟₆₀ second at f8
LIGHTING:
Daylight and accessory flash

Taken at the same Japanese market as the previous shot, the photographer bided his time until the stall holder was engaged in conversation with a customer before shooting. Note the slight ghosting evident in the subject's outstretched hand. This can occur when flash is used in ambient light levels that are high enough to affect the film – the flash exposure has frozen the movement of the subject and is responsible for the overall exposure, but because the photographer had set a slow shutter speed, the shutter was still open while the subject's hand moved, thus causing a faint secondary image to be recorded.

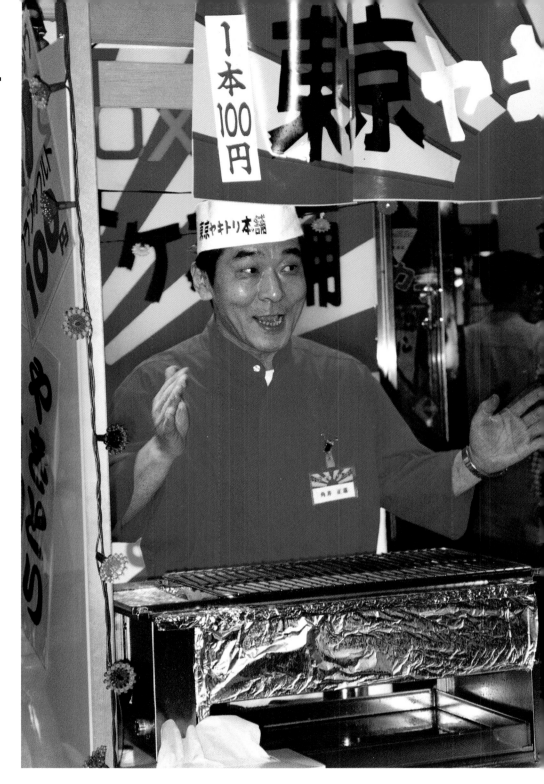

PHOTOGRAPHER:
Frits Jansma
CAMERA:
6 x 4.5cm
LENS:
120mm
FILM:
ISO 100

EXPOSURE:
1/30 second at f5.6
LIGHTING:
Daylight and accessory flash

The depth of interest the environment brings to this image of a man bent over a spade clearing a derelict site is just one of the reasons why many photographers prefer to work outside of the studio. The lighting, too, filtering through the clouds of billowing smoke, has a quality that artificial lighting simply cannot replicate. In situations such as this, however, take your light reading directly from the subject. An overall or averaging reading could take too much account of the light reflecting from the smoke and cause the subject to be underexposed.

PHOTOGRAPHER:
Damian Gillie
CAMERA:
6 x 7cm
LENS:
45mm
FILM:
ISO 125
EXPOSURE:
1/60 second at f8
LIGHTING:
Daylight only

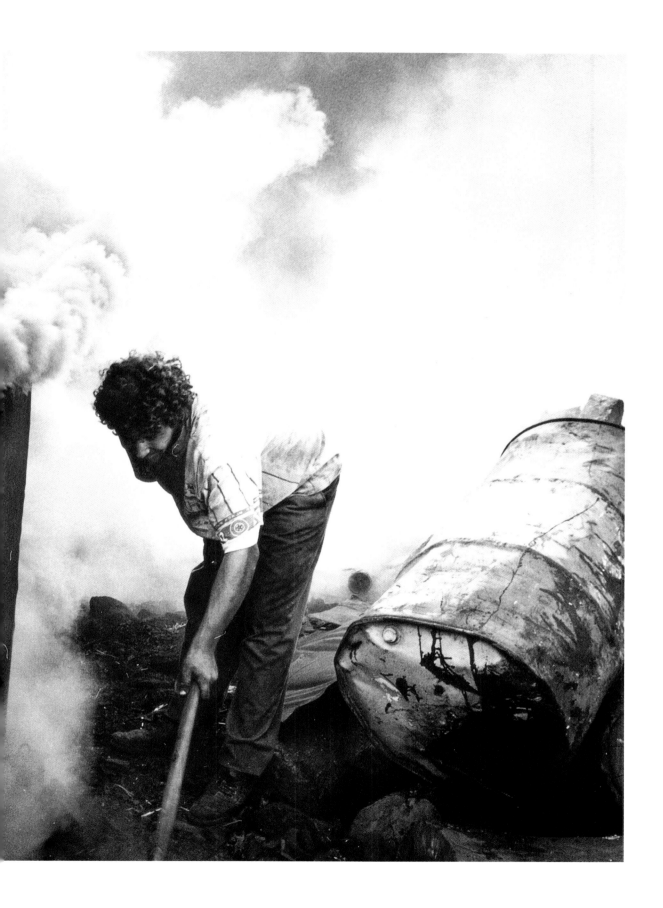

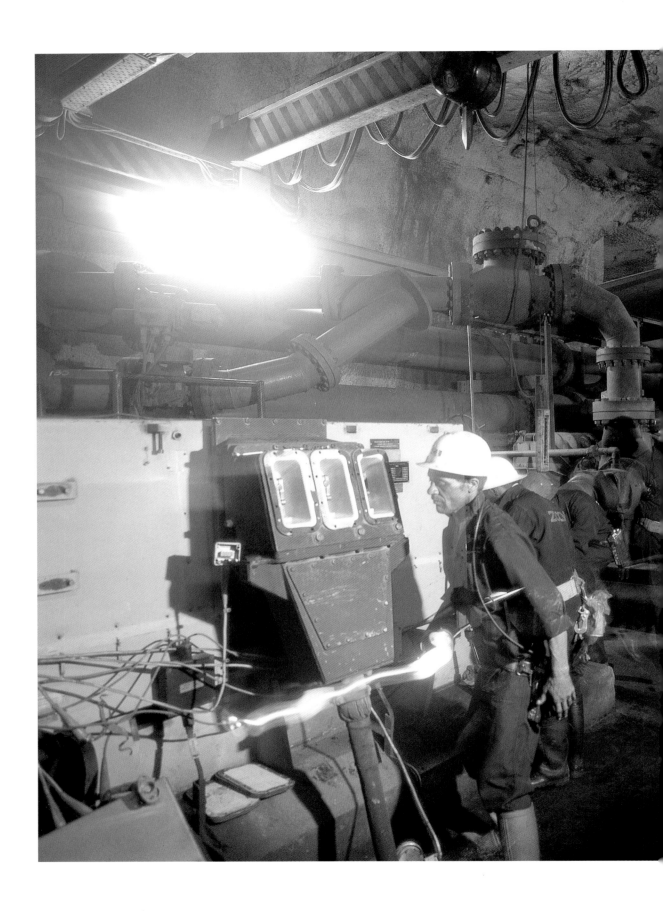

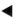

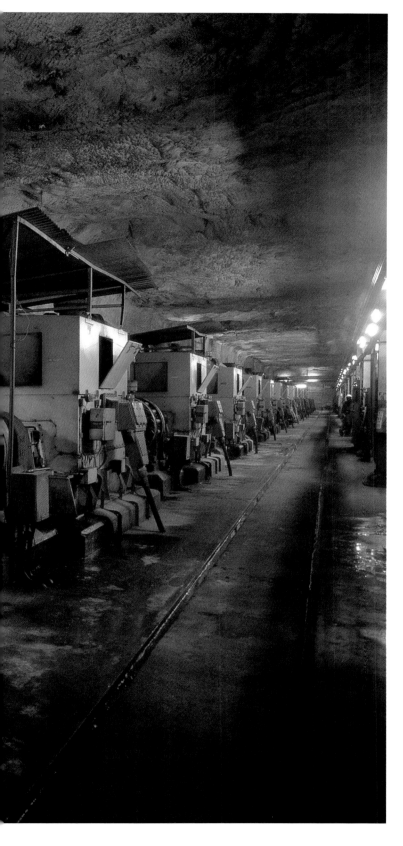

An exposure time of many seconds was required in order to record the dimly-lit line of machinery stretching back to the furthermost reaches of this workplace scene. The main group of workmen, who were illuminated by flash, had to stand as still as they could after the flash had fired for the remainder of the long exposure, but you can see that just beyond this group there is an apparition of another workman. He was walking slowly enough in the glare of the overhead fluorescent lighting to leave his ghostly impression behind on the film but was not in sight when the flash was triggered. A correcting filter was used to prevent the green colour cast that is often produced by many types of fluorescent lighting.

PHOTOGRAPHER:
Damian Gillie
CAMERA:
6 x 7cm
LENS:
45mm
FILM:
ISO 100
EXPOSURE:
12 seconds at f11
LIGHTING:
Flash and available fluorescent lighting

PHOTOGRAPHER:
Damian Gillie
CAMERA:
6 x 7cm
LENS:
400mm
FILM:
ISO 400
EXPOSURE:
5 seconds at f4
LIGHTING:
Flash and available light

◄

Although the usual advice is to avoid direct accessory flash because it produces a stark, uncompromising and rather unflattering lighting effect, this was precisely what the photographer wanted. The sky is a dramatic inky black and the figures appear to have been caught, as if surprised by the sudden burst of light, in the middle of some type of nefarious activity. The only other lighting in the scene came from the powerful spotlights used on the site to allow the men to work after dark, and the effects of this can be seen on the back of the man who is standing, hands on hips.

FLASH BRACKET

When you are using camera-mounted flash – either by preference or because circumstances dictate – the type of flash bracket shown here can be a boon. By lifting the flash head well above the level of the lens any possibility of red-eye is eliminated. This particular bracket is designed to accommodate both 35mm SLRs and 6 x 4.5cm and larger medium format models. It allows both camera types to be used horizontally or vertically while ensuring that the flash remains centred directly above the lens. A cable release runs from the camera to a trigger on the front of the bracket to allow for more convenient operation.

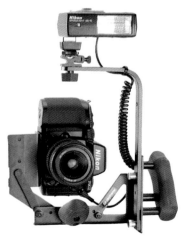

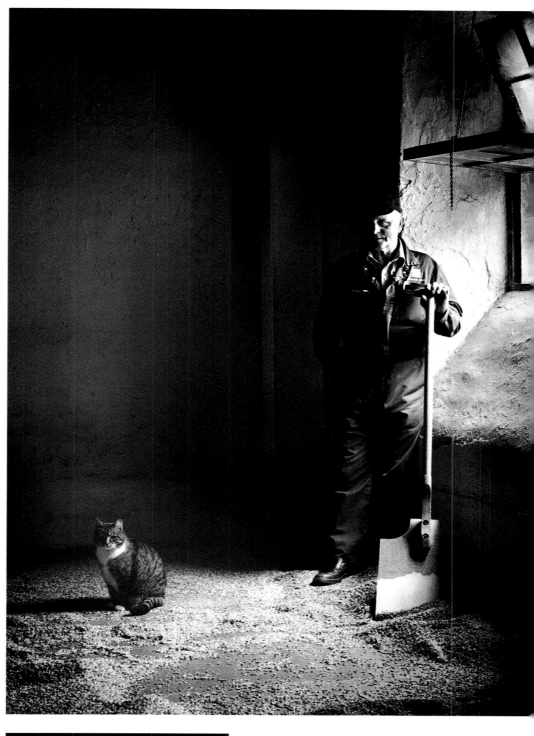

Although stark, limited in extent and lit by daylight from the window to make a series of geometric shapes, the environment is a vital component of this shot. Contrast tends to be high with window light, since the directional lighting can cast shadows that are as strong as the highlights on anything that it falls on. This creates exposure problems: expose for the highlights alone and the rest of the scene may be plunged into uncompromising blackness; expose for the shadows alone and the highlights may be glaringly bright. Here, however, the windows at the top were coated with grime, which acted rather like a diffuser, and the light entering directly through the open windows at the bottom, was first reflected from a building opposite, which had the effect of softening its appearance.

PHOTOGRAPHER:
Damian Gillie
CAMERA:
6 x 7cm
LENS:
135mm

FILM:
ISO 400
Exposure:
¼ second at f4
LIGHTING:
Daylight only

Difficult lighting

THE MOST COMMON PROBLEMS WITH NATURAL LIGHTING that photographers encounter are either when there is very little available light to work with or when the angle or direction of that light is not ideal for your subject.

If you know in advance that you will be working in dim lighting conditions make sure that you take plenty of fast film with you. Only a few years ago, ISO 200–400 film was regarded as 'fast'. However, advances in film technology mean that today you can choose film rated at ISO 3000 and faster, although there will be some loss in picture quality as some image detail will be swallowed up by the increased graininess evident in enlargements or projected slides.

Another way of minimizing the effects of dim lighting is by using the fastest lenses you have at your disposal. A lens set at its maximum aperture of, say, f4, for

TIPS FOR PRINTERS

Under- or overexposed parts of negatives can be printed to give more acceptable results. This information applies specifically to black and white printing, however, since altering the exposure time of coloured printing paper affects not only print density but also the colour balance.

- If parts of a negative are printing too dark in relation to the rest of the image, use a shaped piece of black cardboard attached to a thin piece of non-reflective wire to 'hold back' light from the enlarger over the places where you want lighter results. Just how long into the exposure time you interrupt the enlarger light depends on how dense the shadow is and how light a result you want. Keep the cardboard shape moving all the time to prevent a distinct line of density appearing. When lightening shadows, you will not be able to bring up subject detail that was never recorded.

- If parts of a negative are printing too bright in relation to the rest of the image, use a full-frame piece of black cardboard with holes cut out of it corresponding to the areas of the print that require extra exposure. When the paper overall has received the correct exposure, introduce the sheet of cardboard and allow the lighter parts of the print to 'burn in' through the holes. As with holding back, keep the cardboard moving slightly all the time to prevent a clear break in densities. Burning in can bring up subject detail that would otherwise be lost, but these areas may look a little empty of tone and somewhat unnatural.

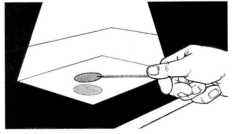

HOLDING BACK
Interrupt the light from the enlarger with a shaped piece of black cardboard attached to wire to hold back light from areas of the paper that are printing too dark.

BURNING IN
Cut a hole in a sheet of black cardboard to allow light from the enlarger to darken an area of the paper that is printing too light.

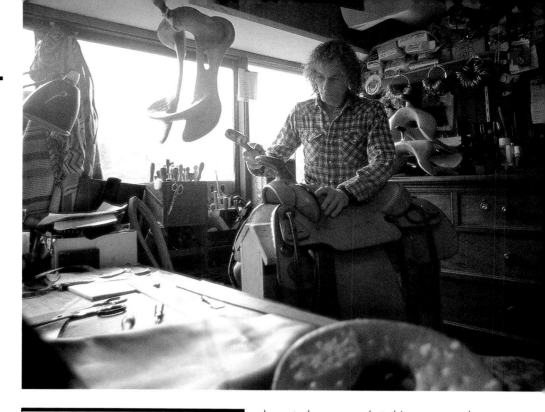

Shooting against the light – when the subject is between the camera and the light source – is one of the classic situations in which the camera's light meter can be fooled. When this occurs, the sensor can be overwhelmed by the light flooding in from around the subject and, as a consequence, select a small aperture and/or a brief shutter speed to compensate. This, however, will probably result in the subject being underexposed or being reduced to a silhouette. If you find yourself confronted with backlighting, take your light reading specifically from the subject, or another shadowy part of the scene, lock those settings into the camera, and then recompose your shot before shooting. Note in this picture that the photographer took his light reading from the interior of the workshop.

PHOTOGRAPHER:	FILM:
Robert Hallmann	**ISO 100**
CAMERA:	EXPOSURE:
6 x 6cm	**1⁄25 second at f5.6**
LENS:	LIGHTING:
50mm	**Daylight only**

example, will allow twice the amount of light to reach the film as does a lens with a maximum aperture of f5.6, and this increase can make a crucial difference. Often, it is the standard lens for your camera format (50–55mm for 35mm cameras and 75–85mm for medium format models) that has the widest maximum aperture. With such lenses, f1.4 is not uncommon.

If, however, you find that you have a relatively slow film in the camera when light levels start to plunge, all may not be lost. Depending on the type of film you are using – black and white negative, colour negative or colour slide – you can override the film speed setting by varying degrees and expose the film as if it were faster than its nominal rating. All frames on that roll will then

have to be exposed at this new speed setting and the processing laboratory will have to be informed so that they can extend the development time (known as 'pushing') to compensate for what is effectively underexposure. Uprated film may have to be hand processed and this will then be more expensive. If pushed to the limits, uprated film will suffer noticeably in terms of image quality and its contrast response.

When the direction of the light is not ideal – perhaps it is coming from the rear of the subject or it is very directional – you may have to make a decision about which part of the picture area is most important for you to record. If this situation does arise, take your light reading specifically from that part of the scene, set the camera controls accordingly, and allow the detail in other areas of the frame to over- or underexpose. You may be able to rescue these parts of the image later at the printing stage.

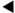

In a characteristic pose, Pope John Paul II is seen here with his head bowed in prayer. The difficulty for the photographer in this portrait was to light the subject using only a powerful accessory flashgun without the light glaring back from his white vestments and the rich gold decoration of his chair. The solution was to use a makeshift diffuser of tracing paper taped over the flash head. The sensor on the flashgun automatically compensated for the presence of the tracing paper, which, by spreading the beam of light, caused some loss of illumination.

PHOTOGRAPHER:
Livio Anticoli /FSP/Gamma
CAMERA:
35mm
LENS:
105mm
FILM:
ISO 200
EXPOSURE:
1⁄60 second at f4
LIGHTING:
Accessory flash

▲

Stage lighting presents many problems for the photographer. Often a light reading indicates an exposure setting of a second or more, even when, to the naked eye, light levels appear to be quite bright. Also, what light is available is likely to cause all manner of colour casts. At this stage performance, the photographer uprated the film by 2 stops in order to allow a successful hand-held exposure and, pragmatically, decided that any resulting colour casts would only add to the atmosphere of the scene.

PHOTOGRAPHER:
Ghislaine Morel /FSP/Gamma
CAMERA:
35mm
LENS:
135mm
FILM:
ISO 200 (uprated x 2 stops)
EXPOSURE:
⅟₆₀ second at f4.5
LIGHTING:
Mixed stage lighting

Judging exposure for night-time shots is always problematic, since it is impossible to tell until you see the finished images whether of not you have achieved the correct balance between areas of the scene adjacent to any light sources and those parts of the scene in more complete darkness. In such situations, if time allows, it is best to bracket your exposures – taking shots at a range of exposure settings either side of what you (or the camera meter) judge to be correct – and choose the best example afterwards. In this candle-lit ceremony outside St Peter's in the Vatican City, it is interesting to note the different colour temperatures of the white-coloured floodlighting illuminating the building, the yellow of the street lighting, and the warm orange of the candle flames. Another feature of night shots in which there are bright point sources of light is a phenomenon known as 'halation'. Halation appears as a spreading area of light around each of these sources and is caused when individual rays of light penetrate right through the film emulsion and reflect back up to the surface again from the plastic film base, spreading out as they go.

PHOTOGRAPHER:
Livio Anticoli/FSP
CAMERA:
35mm
LENS:
28mm
FILM:
ISO 200
EXPOSURE:
3 seconds at f5.6
LIGHTING:
Mixed lighting

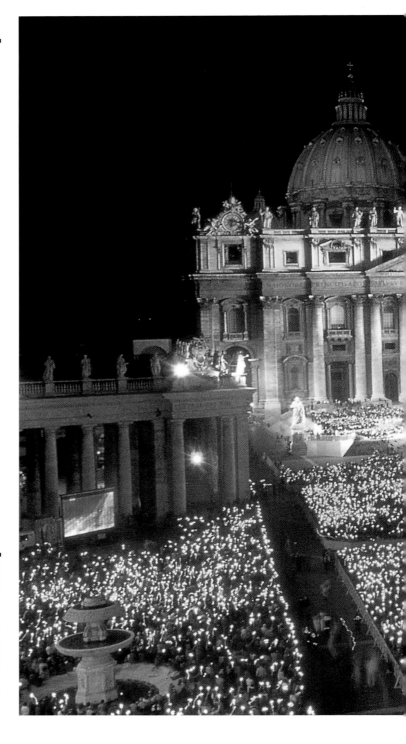

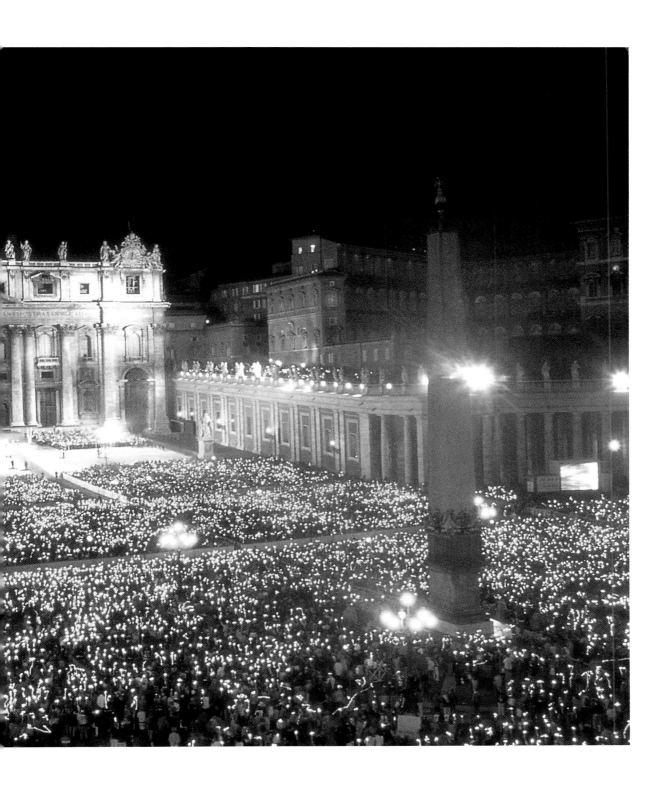

Although the sky was overcast, the light levels were not particularly poor on the streets of New York where this amusing double portrait was shot. Contrast, however, was very flat, and the white uniforms of the workmen flanking the advertisement for Obsession for Men did not appear tonally much different from the grey marble fascia of the building. To increase contrast and improve the appearance of both the subjects and the surroundings, the photographer used camera-mounted accessory flash set to half the recommended power setting. This was enough to lighten their clothing without producing a too intense flash 'hot spot' on the glass window behind. If this hot spot had been any brighter it might have obliterated at least part of the window display's message and thus weakened the impact of the humour of the image.

PHOTOGRAPHER:
Linda Sole
CAMERA:
35mm
LENS:
85mm
FILM:
ISO 200
EXPOSURE:
⅟₆₀ second at f8
LIGHTING:
Daylight and accessory flash

WORKING TO A THEME

Under arms

A STRONG MARTIAL TRADITION RUNS THROUGH MOST CULTURES and nationalities, and images of men under arms carry with them many powerful emotional connotations. Thus, it is not surprising that the camera has accompanied military campaigns ever since its inception, even at a time when glass plates had to be prepared, exposed and then processed in special tents set up on the fringes of the battlefield itself.

Cameras, and the military, are of course very different today. Mobile, high-tech and, above all, professional, all branches of the armed forces have a need to communicate their rapidly changing roles to the governments they serve and, in most cases, ultimately to the electorate on which those governments depend. Not only does the military need to attract the right type of personnel, it also has to justify the enormous amounts of money it costs to equip and maintain the modern military machine. With this in mind, professional photographers with a legitimate interest in recording the many and varied aspects of military activity are likely to be met with a helpful response, especially if the authorities feel that the material will be used to promote the military and show it in a positive light to the widest possible audience.

PHOTOGRAPHER:
Xinhua/FSP/ Gamma
CAMERA:
35mm
LENS:
28mm
FILM:
ISO 200
EXPOSURE:
⅟₂₅ second at f16
LIGHTING:
Daylight only

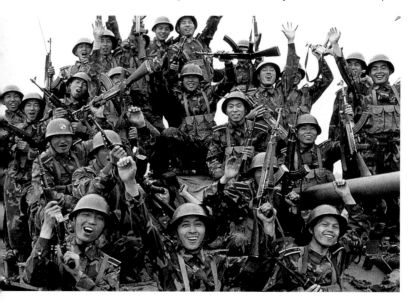

Under the most favourable of circumstances, organizing a group photograph involving this many people has its problems, but when your subjects are soldiers arranged on the top of a battlefield tank the difficulties are multiplied. The photographer has taken excellent advantage of the different surfaces of the tank, with some standing on the ground, others squatting or standing on the gun turret and so on to try both to make a pleasing arrangement and to ensure that all faces can be clearly seen. At the point of taking the picture, the photographer encouraged everybody to cheer at precisely the same instant to give the shot its important sense of animation.

This dramatic image of a gun position on a naval patrol boat is especially successful because of the way the photographer has brought all the vital elements together, with the main points of interest being confined within the circular frame that forms part of the gun sight. If the camera position had been just inches left or right, up or down, then the gunner's eye would not be seen to align with the eyepiece.

PHOTOGRAPHER:
Giansanti/FSP/ Gamma
CAMERA:
35mm
LENS:
28mm
FILM:
ISO 100
EXPOSURE:
$\frac{1}{250}$ second at f8
LIGHTING:
Daylight only

Depth of field has been used to good effect here to emphasize the foreground soldier by showing him as the only one who is critically sharp and thereby differentiating the various image planes.

PHOTOGRAPHER:
FSP/Gamma
CAMERA:
35mm
LENS:
135mm
FILM:
ISO 100
EXPOSURE:
¹⁄₆₀ second at f5.6
LIGHTING:
Daylight only

Dressed in arctic camouflage and aiming his weapon almost directly into the camera lens, this rifleman makes an exciting image. With simulated battlefield smoke obliterating all but the subject. it is possible to imagine the tension, confusion and fear of real life-and-death conflict. This, however, is a picture taken at a training exercise, so the photographer had time to make a bracketed series of exposures to ensure that the soldier's white outer clothing and the light-scattering smoke did not confuse the camera's light meter.

PHOTOGRAPHER:
FSP/Gamma
CAMERA:
35mm
LENS:
180mm
FILM:
ISO 100
EXPOSURE:
1/25 second at f8
LIGHTING:
Daylight only

Religious observance

RELIGIOUS FORMS, CEREMONIES, COLOURS, SYMBOLISM AND PRACTICES are so varied that they make fascinating subjects for the camera. Human emotion, too, from the joy and hope of marriage and birth to the sadness and desolation of death, all find expression in religious observance and, if handled with sensitivity, are there to be recorded. Also, for photographers with an interest in architectural photography, religious buildings, traditional and more contemporary, can be an endless delight.

Unless permission is sought and obtained for the use of artificial light when working indoors, you will almost always be restricted to whatever available light is present. This may be daylight or artificial lighting (probably domestic tungsten in its colour temperature), or a mixture of the two – so be aware of the potential problem of colour casts. Daylight entering through windows or doors can sometimes be difficult to work with, since it may adequately illuminate anything immediately adjacent to them without necessarily penetrating too far into a large interior, and this could make contrast a potential problem.

It is not wise to assume that photography is allowed in all religious buildings or during all religious services. If you are in any doubt, always check first that the camera will not cause any disturbance or offence. Even when photography is permitted, cameras with built-in autowinders, beeping warning signals and noisy shutters, may not be appreciated. If your camera permits, turn off any audible warning signals and, if your camera is noisy in operation, you may be able to buy a sound-dampening blimp for your particular model.

PHOTOGRAPHER:
**Quidu-Ribeiro/
FSP/Gamma**
CAMERA:
35mm
LENS:
35mm
FILM:
**ISO 400 (uprated x
1 stop)**
EXPOSURE:
⅟₆₀ second at f4
LIGHTING:
Domestic tungsten

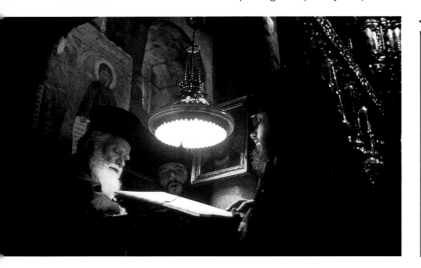

Illuminated by the harsh glow of an overhead light, this scene is full of atmosphere. The light was difficult to work with and the photographer uprated the film by a stop in order to achieve a little more exposure latitude. Timing, too, was crucial, since despite the increase in film speed, a slow shutter speed was still required, and so the shot had to be taken when the subjects were nearly stationary. Also, had any of the participants swayed back, their faces would have been immediately swallowed up in shadow.

Changing times and shifting attitudes can be seen in these two images – only a few years ago these communion and christening scenes would have been impossible, since women were not then admitted to the priesthood of the Anglican church. The interior of the church was surprisingly bright, lit by large windows piercing the surrounding walls. Also, there was a good level of tungsten lighting in the building, but colour cast is not an issue when you are working in black and white.

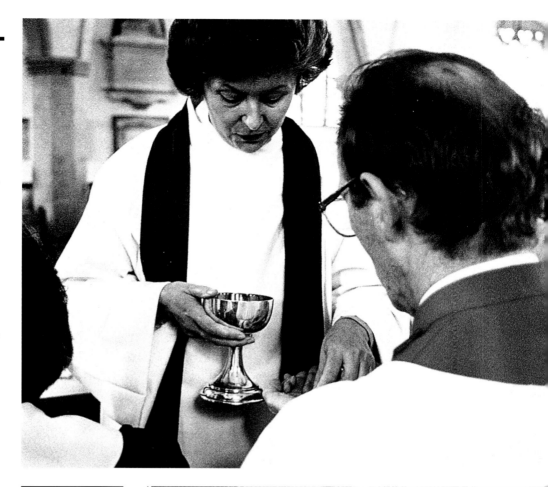

Marsha Arnold/FSP/ Gamma
CAMERA:
35mm
LENS:
80mm
FILM:
ISO 100
EXPOSURE:
$\frac{1}{125}$ second at f8
LIGHTING:
Daylight and tungsten

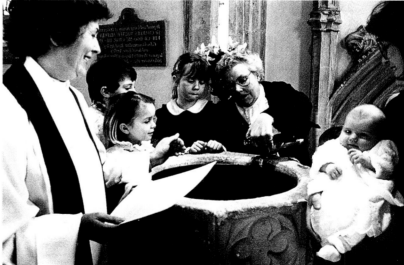

▲

The photographer needed special permission to be in the bell tower when this wonderfully funny picture was taken of a priest manually ringing an enormous bell while wearing ear protectors. The photographer, too, needed ear protection, but even so the pressure, noise and vibration were painful.

PHOTOGRAPHER:
Esaias Baitel /FSP/Gamma
CAMERA:
35mm
LENS:
28mm
FILM:
ISO 50
EXPOSURE:
1/125 second at f5.6
LIGHTING:
Daylight only

▶

An overhead view inside this Buddhist temple was the ideal way to record the wonderful patterns of colour produced by the clothing of the worshippers below. Not only that, the bright decorated columns and floor tiles could also be best recorded from high up, since then there would be no possibility of the daylight from outside flaring directly into the camera lens and spoiling the image.

PHOTOGRAPHER:
Jean Claude Labbe/FSP/Gamma
CAMERA:
35mm
LENS:
28mm
FILM:
ISO 100
EXPOSURE:
1/125 second at f5.6
LIGHTING:
Daylight only

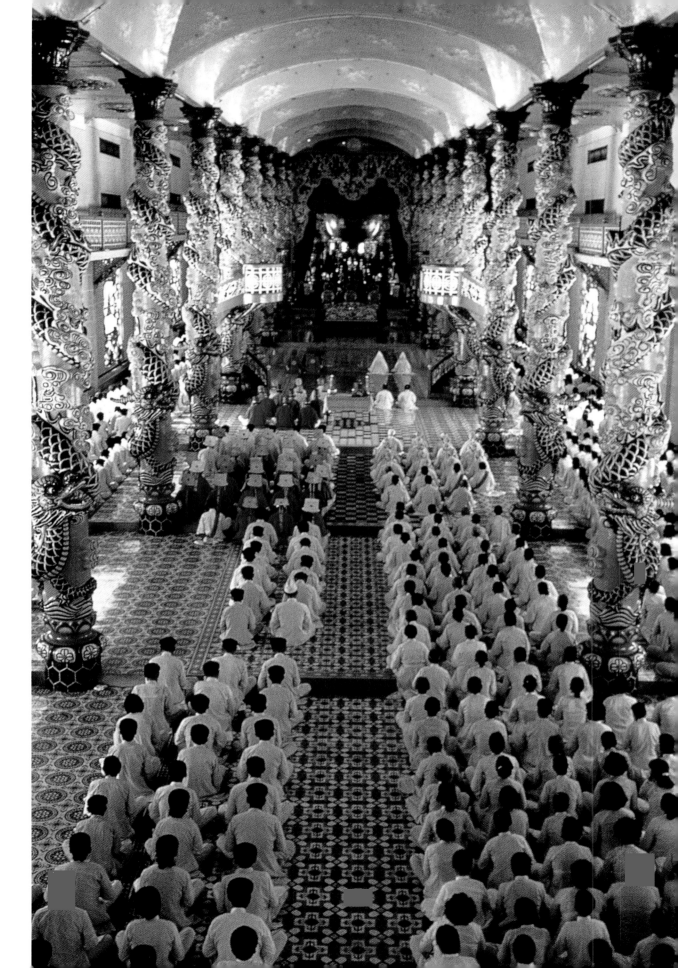

Although the nave of this Catholic church is full of people, the photographer is so high up under the central dome that they have been reduced to mere pattern. Instead, the features that dominate this image are the majestic architectural features and detailing of the building.

PHOTOGRAPHER:
Sestini Agency /FSP/Gamma
CAMERA:
35mm
LENS:
28mm
FILM:
ISO 200
EXPOSURE:
⅟₆₀ second at f8
LIGHTING:
Daylight only

Close attention to framing was the crucial factor in the success of this picture, in which the photographer adjusted the zoom setting of the camera lens so that its angle of view encompassed only a block of ladies who were wearing a straw bonnet of some type.

PHOTOGRAPHER:
**Tixador/FSP/
Gamma**
CAMERA:
35mm
LENS:
**28–80mm zoom
(set at 80mm)**
FILM:
ISO 50
EXPOSURE:
⅙₀ second at f11
LIGHTING:
Daylight only

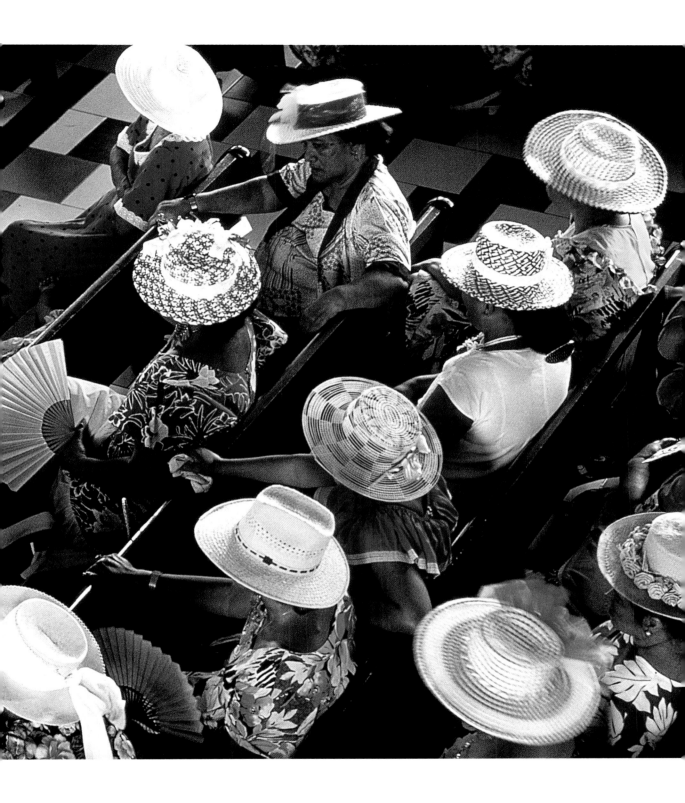

For religious
Muslims, a
pilgrimage to
Mecca, where this
photograph was
taken, is a crucial
journey of great
spiritual
importance – one
that must be
undertaken at
least once in a
lifetime. Light
levels inside the
mosque were not
high, but the
photographer
timed the picture
well, shooting just
after the
worshippers had
sat back upright
again and were
practically
stationary. This
allowed a slow
shutter speed to
be set (without
introducing subject
movement) so that
a compensating
small aperture
could be selected
in order to
maximize depth of
field.

PHOTOGRAPHER:
**Bruno Hadjih/FSP/
Gamma**
CAMERA:
35mm
LENS:
18mm
FILM:
ISO 200
EXPOSURE:
1/30 second at f8
LIGHTING:
Daylight only

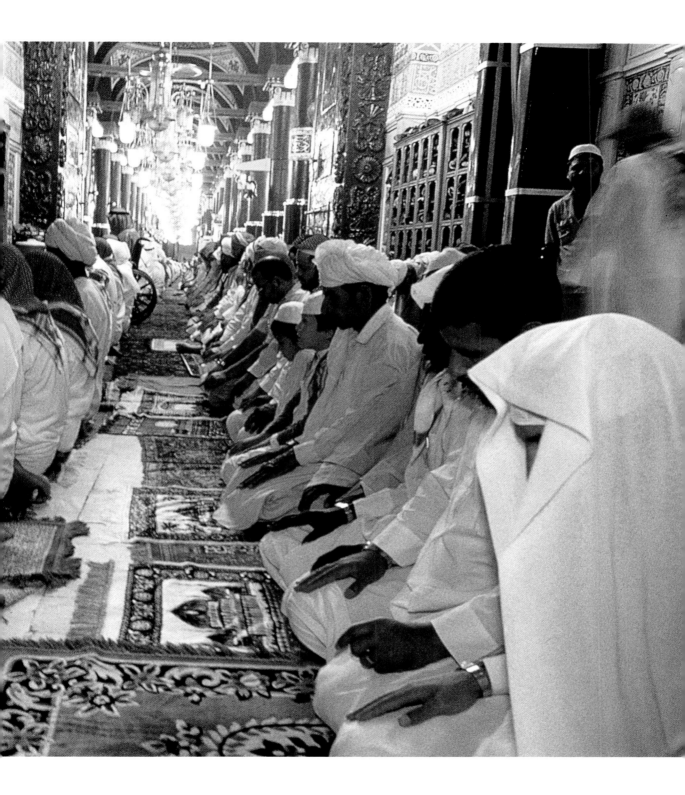

Corporate photography

COMPANIES LARGE OR SMALL, PUBLIC SECTOR OR PRIVATE, all at some stage have to sell themselves to their clients or customers by presenting a particular slant on their activities. Often, this is partly achieved photographically, perhaps by publishing a carefully composed view not only of the people who are the subjects of the shots but also of the environments in which they are seen. It could be, for example, that a company is contemplating a shares issue and needs to generate as wide an interest as possible by increasing its public profile. In this situation, an option could be to produce a glossy brochure or newspaper advertisement showing key personnel in a setting that is designed to create just the right impression.

In another example, a public utility may be interested in showing the sector it serves that it is taking their worries, concerns and points of view into account and is prepared to adjust its procedures to fulfil public expectations. Equally likely, of course, it is the appearance of corporate concern that is important to communicate to the utility's audience, even if there is little substantial change in actual practices.

Corporate photographs are also often used in the public spaces of the headquarters, factories or agencies of companies – in reception areas, for example, meeting rooms, or anywhere that clients or members of the public will see them. Similarly, public companies may commission a series of photographs to accompany their annual reports to shareholders. Rather than page after page of dry columns of figures, balance sheets and projections, this same information could be integrated

PHOTOGRAPHER:
Strat Mastoris
CAMERA:
6 x 6cm
LENS:
50mm
FILM:
ISO 100
EXPOSURE:
½₅₀ second at f8
LIGHTING:
Daylight only

◄

 This series of photographs was commissioned to show aspects of a train operator's business. The photographer decided to take this wide-angle establishing shot to give an impression of the diversity and complexity of a modern railway system. The location – a footbridge over a busy goodsyard – was scouted beforehand, but the photographer then had to wait until both the lighting was perfect and the personnel on the ground below were well positioned. The length of the cast shadows indicates that the sun was low in the sky when the shot was taken, and the afternoon sun also has the first touch of the rosy warmth, which adds to the appeal of the image.

PROFESSIONAL APPROACH

- The first stage in undertaking a series of corporate photographs is to arrange in-depth meeting with the key personnel involved with the project, those who know precisely what impression the photographs are intended to produce and how exactly they are going to be used – in a magazine or newspaper, for example, to accompany an annual report, or as part of a full-blown sound-and-vision presentation. Picture requirements, such as format, could vary.

- At this meeting, or subsequent ones, ask all you need to know regarding the premises you will be working in. It may be that pictures will be taken in a range of different environments – corporate headquarters, on the factory floor, on a building site, at a mine entrance, in a truck marshalling yard, or wherever is most relevant to the business of the client.

- Before deciding on your photographic approach, it may be that you have to visit all of the potential shooting sites, so build the time this will involve into your quote. Make notes at each site regarding the type of equipment you will need (lights, cables, etc) and shoot some Polaroids so that you have visual reference of each place.

- Having absorbed the background briefing from the client and visited the sites of the proposed shoots, come back with a potential shot list. Explain to the client the approach you plan to take and your thinking behind this strategy.

- Once this is agreed, draw up a realistic shooting schedule, detailing all the people and props you will need, where and when.

with well-conceived, confidence-inspiring photographs, even when they are printed very faintly and used as a background to the text.

▲

Moving down into the goodsyard seen in the previous picture, the photographer took this shot of a railways manager holding the report that had prompted the series of photographs. The strength of the image depends on the colour and livery of the locomotive behind picking up on the colours of the safety jacket and hard hat of the subject. Attention to detail is crucial in work such as this, and the photographer adjusted the angle of the folder so that it was not directly facing the sun, which was flaring off the white background. Although the environment around the subject here is limited, it makes all the difference to the success of the image.

PHOTOGRAPHER:
Strat Mastoris
CAMERA:
6 x 6cm
LENS:
50mm
FILM:
ISO 100
EXPOSURE:
1/125 second at f11
LIGHTING:
Daylight only

◀

Track maintenance is an obvious aspect of railway safety and so this image formed part of a series of photographs taken to accompany a report on railway safety practices. Framing was important, since the picture had to show both the welder at work and enough of the background for the maintenance yard to be recognizable. The prominent position of the fire extinguisher was not accidental – details such as this all help to reinforce the message of safety consciousness.

PHOTOGRAPHER:
Strat Mastoris
CAMERA:
6 x 6cm
LENS:
50mm
FILM:
ISO 100
EXPOSURE:
¼ second at f11
LIGHTING:
Daylight and studio flash x 2 (both fitted with reflective umbrellas)

There were a lot of exposures to balance in this picture of a track welder at work. One studio flash unit was positioned adjacent to the camera position to illuminate the subject's head and chest, while a second was placed out of shot to the left of the camera to make sure the zigzag weld on the track was prominently lit. Both flashes were fitted with reflective umbrellas to produce a softer, less direct effect. The power of the lights then had to be adjusted so that a single exposure would accommodate them and the daylight illuminating the background.

This image might appeal to somebody who takes their cigar smoking very seriously indeed. The picture shows the humidified vault of a leading tobacco company, where customers' cigars are stored in their own personal safes. The figure, although small in the frame, plays a vital role, giving not only scale to the environment but also – because of his clothing and pose – a sense of solid dependability. Space was tight in the vault, which made a wide-angle lens the only practicable choice, and in order to bring out the richness of colour of the wooden panelling, the only light sources used were the unfiltered tungsten lights in the ceiling. Light levels were very low, however, making a time exposure essential.

PHOTOGRAPHER:
Strat Mastoris
CAMERA:
6 x 6cm
LENS:
40mm
FILM:
ISO 100
EXPOSURE:
5 seconds at f8
LIGHTING:
Domestic tungsten lighting

This image was commissioned by a public relations company for use in an advertising brochure. The idea was to show the elegance of their offices and, hence, imply the success of the company. To this end, the best angle was determined for the enormous leaded-lights and then the foreground was carefully propped with plants and flowers to give an informal, but business-like, appearance. Lighting for the shot was natural, that coming in through the wall of glass. Smaller windows would probably have provided sufficient illumination for the subjects as well, but the smaller the light source (the window in this example) the more directional its effect, and so a reflector may then have been necessary to brighten any over-dense shadows.

PHOTOGRAPHER:	FILM:
Strat Mastoris	**ISO 100**
CAMERA:	EXPOSURE:
6 x 6cm	**½ second at f11**
LENS:	LIGHTING:
40mm	**Daylight only**

This is a brochure photograph for a public relations company showing a supposedly candid shot of typical office activity. In fact, it was very carefully lit with two studio flash units so that the paperwork on the desk was well recorded without the detail on the screen being obscured. After the flashes had fired, both subjects had to stay perfectly still for a manually timed exposure of a full second – the length of time necessary for the information on the computer screen to record properly.

PHOTOGRAPHER:	EXPOSURE:
Strat Mastoris	**1 second at f22**
CAMERA:	LIGHTING:
6 x 6cm	**Studio flash x 2**
LENS:	**(both fitted with**
40mm	**reflective**
FILM:	**umbrellas)**
ISO 100	

Carnival time

CARNIVALS, AND OTHER MAJOR PUBLIC PERFORMANCE EVENTS, are usually planned and advertised well in advance, and this allows you plenty of time to prepare. It may be, for example, that you time a holiday or business trip to a specific city or country in order to coincide with one of these events, or you may live locally – in which case you may be familiar with the layout of the venue. But no matter which category you fall into, find out beforehand any information that will make your photographic coverage more successful.

The event featured on these pages is the Notting Hill Carnival, which is held annually in the inner-London suburb of Notting Hill over a three-day period (weather permitting) during the August bank holiday. This carnival is by far the largest Caribbean festival held anywhere in Europe and attracts news photographers and freelancers from around the world. There are so many activities, floats, bands, dancers, food vendors and revellers that the carnival stretches over a meandering route of narrow suburban streets. Information leaflets available from the organizers provide the precise route of the procession and other useful information, such as transport arrangements for those wishing to attend. Also, different activities occur at different times over the holiday weekend – the first day, for example, is traditionally designated as child's day.

PHOTOGRAPHER:
Tim Ridley

CAMERA:
35mm

LENS:
**70–210mm zoom
(set at 90mm)**

FILM:
ISO 100

EXPOSURE:
1/25 second at f2.8

LIGHTING:
Daylight only

PREPARING FOR CARNIVAL

- The earlier you get to the event the better your chances of finding a good camera position.
- When you are shooting in a crowd the last thing you want is the bother of excess equipment, so pare things down to a minimum.
- A wide-angle lens is useful when you are close in to the action and can't move far enough back to use a longer lens, while a moderate telephoto is perfect for isolating individual faces or figures or for cropping out irrelevant or distracting parts of a scene.
- Ideally, a single, wide-ranging zoom lens will cover most situations – something in the range of 28–105mm (or longer) on a 35mm camera.
- Medium-format cameras give superb-quality results, but these are usually much heavier to carry around and slower to use than 35mm cameras.
- Keep the front of your lens protected at all times. Unless you are shooting with a polarizing or some type of special effects filter, use a UV filter over the lens to protect it from dust, dirt and accidental finger marks.
- Wearing clothes with plenty of deep, secure pockets can relieve you of the burden of carrying around a camera bag.
- Take more film with you than you think you will need. Decide on which type of film to use when the likely weather conditions are known. In bright, sunny weather, use the slowest film you think you can get away with. The slower the film, the finer the grain response – and this can be significant when big enlargements are called for.
- Take spare batteries for any of your equipment that depends on battery power.

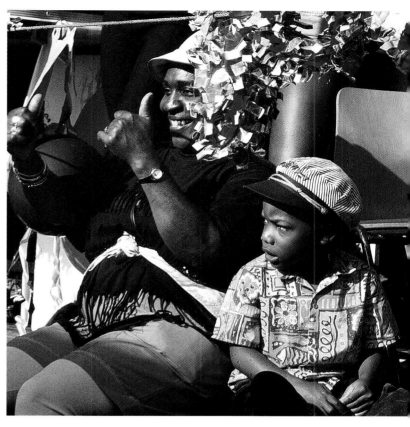

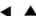

Traditionally, the first day of the Notting Hill carnival is nominated as children's day, and knowing this in advance can help you to plan your coverage. The profusion of cameras at events such as the carnival works in your favour, since you will easily blend in. And with so many shutters clicking in all directions, people simply take no notice and you can shoot pretty well whatever attracts your attention. With children as your subjects, it is best to shoot from approximately their eyeline – shooting from the height of a standing adult will make them look smaller, it emphasizes the tops of their heads, fails to show their faces properly and, often, diminishes the impact of your photographs.

PHOTOGRAPHER:
Tim Ridley
CAMERA:
35mm
LENS:
70–210mm zoom (set at 70mm)
FILM:
ISO 100
EXPOSURE:
1/25 second at f5.6
LIGHTING:
Daylight only

Even with the colour, noise, activity and excitement all about you, try to keep alert to any particularly attractive lighting effects. When contrast is high, as was the case in this scene at the carnival, it can be better to shoot against the light – as long as you compensate the exposure for the fact that the side of the subject facing the camera will be in shadow. Backlighting also has the effect of throwing subjects' shadows towards the camera, which can be an eyecatching feature in a photograph.

PHOTOGRAPHER:
Tim Ridley
CAMERA:
35mm
LENS:
28–70mm zoom (set at 35mm)
FILM:
ISO 100
EXPOSURE:
$\frac{1}{125}$ second at f8
LIGHTING:
Daylight only

By squatting down to take this shot, the effect the photographer has created has been to show the environment from the child's perspective, with the legs of the surrounding adults looking like a forest of tree trunks.

PHOTOGRAPHER:
Tim Ridley
CAMERA:
35mm
LENS:
70–210mm zoom (set at 85mm)
FILM:
ISO 100
EXPOSURE:
$\frac{1}{125}$ second at f5.6
LIGHTING:
Daylight only

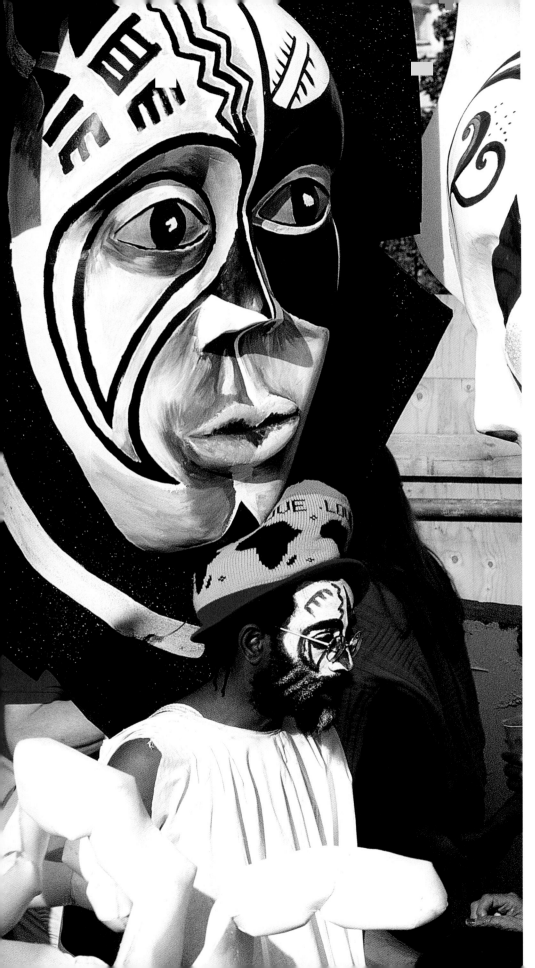

The environment is such an integral part of this carnival photograph that subject and background are utterly inseparable. In order to obtain this unobstructed view of the scene, the photographer stood on metal railings edging the road so that he could shoot above the heads of the intervening crowd.

PHOTOGRAPHER:
Tim Ridley
CAMERA:
35mm
LENS:
70–210mm zoom (set at 210mm)
FILM:
ISO 100
EXPOSURE:
1/60 second at f8
LIGHTING:
Daylight only

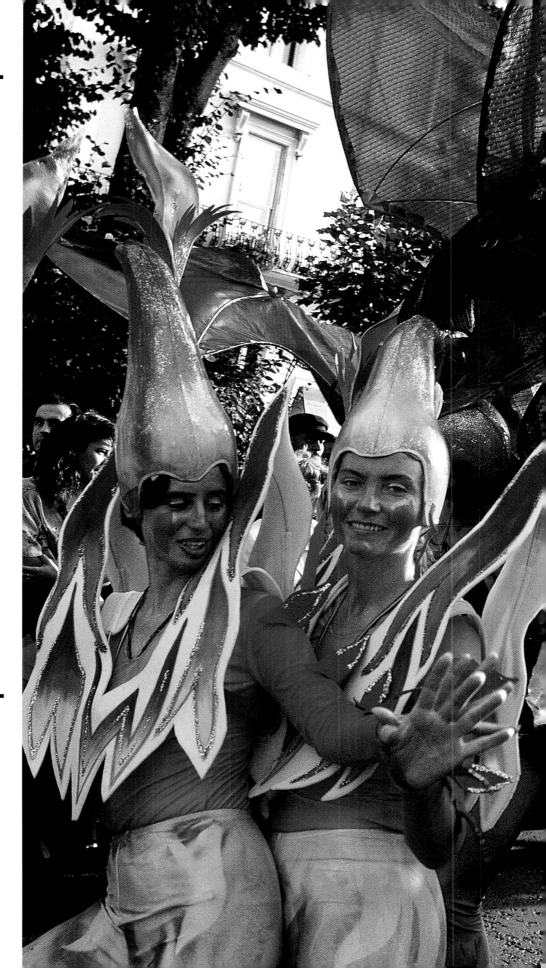

The advantage of
arriving early at
events such as this
is that you can
secure a prime
position on the
procession route
of the performers.
Moving forward as
far as he possibly
could without
becoming caught
up in the crowds,
the photographer
opted to use a
moderate wide-
angle setting on
his zoom lens. The
colours of the
extravagant
costumes in the
background make
a perfect setting
for the dancers.

PHOTOGRAPHER:
Tim Ridley
CAMERA:
35mm
LENS:
**28–70mm zoom
(set at 40mm)**
FILM:
ISO 100
EXPOSURE:
¹⁄₁₂₅ second at f8
LIGHTING:
Daylight only

The Argentinean gaucho

PHOTOGRAPHER:
Aldo Sessa
CAMERA:
6 x 7cm
LENS:
75mm
FILM:
ISO 100
EXPOSURE:
¹⁄₂₅ second at f11
LIGHTING:
Daylight only

THE GOLDEN AGE OF THE GAUCHO lasted probably for about a hundred years, until the mid-19th century, during which time these nomadic, colourful and highly skilled horsemen and animal handlers of the Argentinean pampas (flat grasslands) attained the folk-hero status of the North American cowboy. These proud, strikingly attractive and free-spirited people are often of mixed European and Indian ancestry and, through their own ballads, legends, songs and music, have become an integral part of Argentinean culture and an enduring symbol of that country's open-plained landscape, high skies and achingly distant horizons.

Easily recognizable by their costume, consisting of a chiripa around the waist, a woollen poncho and accordion-pleated

◀

When the day's work is done and the steadily lengthening shadows herald the sinking of the sun, this is when the often punishing daytime temperatures moderate enough for music and dancing. Using seated figures to fill the immediate foreground, the photographer has framed this photograph to show the twirling skirts of the gaucho women in the middle ground and, in the background, the still saddled horses waiting for the men who must soon ride out again to watch over the cattle through the night.

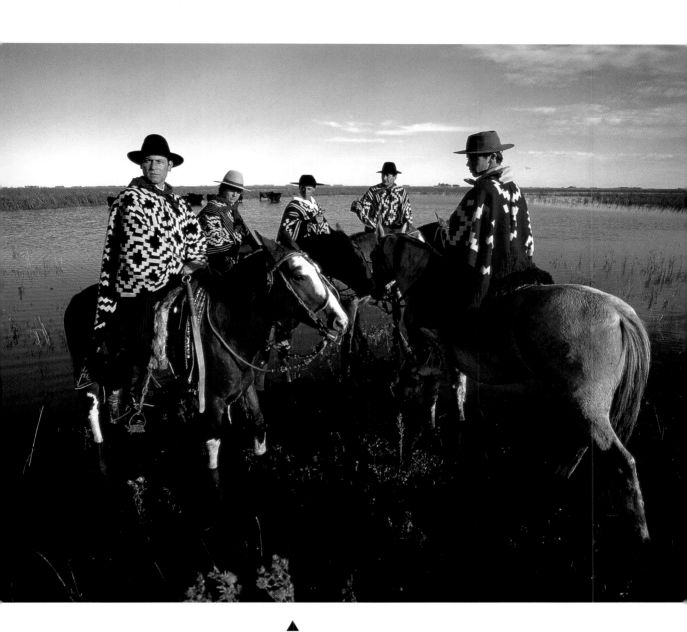

▲

trousers covering the tops of their boots, gauchos originally came to prominence hunting the herds of wild cattle and horses that roamed freely on the vast pampas. However, by the latter half of the 19th century, much of the pampas had been fenced to form the huge estates of rural Argentina today. Moving with the times, the gaucho transformed himself into a farmhand. But the traditions remain and the

When you are photographing people at work, especially if your subjects are responsible for the welfare of a herd of often unpredictable cattle, posed pictures such as this need to be organized quickly. The photographer had time to squeeze off a few quick frames only before the gauchos had to disburse once more to tend to their duties. Early morning on the pampas can be icily cold, and so the colourful woollen ponchos are as practical as they are picturesque.

PHOTOGRAPHER:
Aldo Sessa
CAMERA:
6 x 7cm
LENS:
45mm
FILM:
ISO 100
EXPOSURE:
¹⁄₂₅ second at f8
LIGHTING:
Daylight only

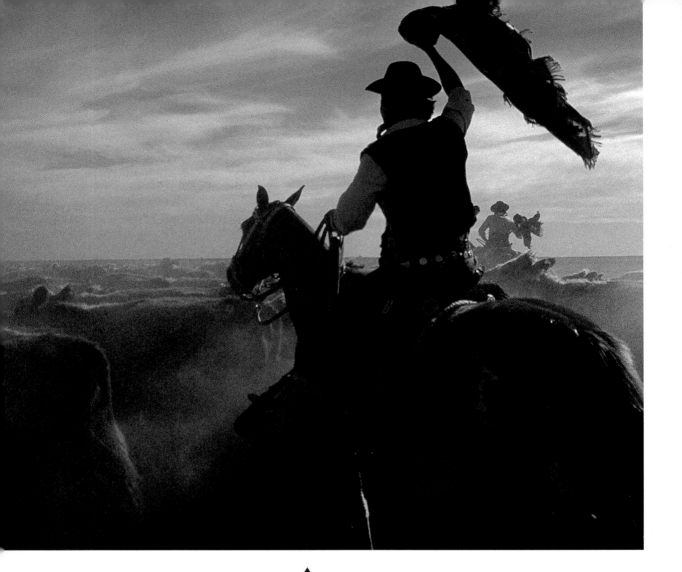

▲

gaucho is still very much a part of modern Argentina. Today it is estimated that there are 150,000 gauchos taking care of about 55 million cattle, 25 million sheep and 2 million horses.

There is an element of danger whenever you work this close to cattle, not just for the gauchos but also for the photographer. Shot from horseback, dust flying everywhere and the excitement of the restless cattle and wildly gesticulating men, the noise and smell almost overwhelming. This is when you appreciate using a lightweight, reliably automated 35mm camera.

PHOTOGRAPHER:
Aldo Sessa
CAMERA:
35mm
LENS:
80mm
FILM:
ISO 10
EXPOSURE:
½50 second at f5.6
LIGHTING:
Daylight only

▲

Even for those who work the dramatic landscape of the Argentinean pampas and have seen the same splendours time and time again, there can be nothing other than quiet reverence for the magnificent series of waterfalls at Iguazú, Misiones Province, here seen with the early dusk light backlighting the foreground figures.

PHOTOGRAPHER:	FILM:
Aldo Sessa	ISO 100
CAMERA:	EXPOSURE:
6 x 7cm	1/60 second at f11
LENS:	LIGHTING:
75mm	Daylight only

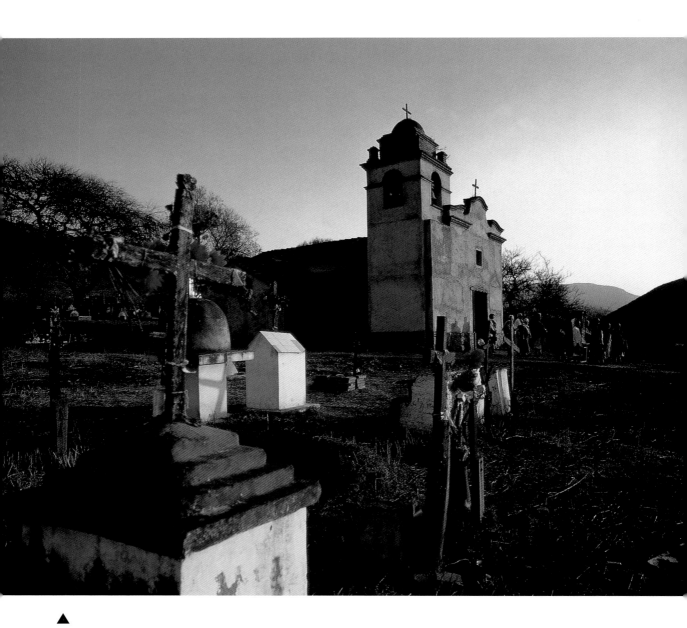

▲

The language is Spanish, the religion Roman Catholicism – twin legacies of centuries-old European colonialism. The photographer had already spent many months living and working with the gauchos and there would have been no objection to his moving in with his camera to take close-up shots of this religious ceremony. However, he preferred to adopt a distant shooting position in order to show the figures in a fuller landscape, one that tries to communicate to the viewer something of the environment that has shaped and moulded the way of life of his subjects. Also, this particular shooting position made perfect use of the church's ancient graveyard as a striking foreground feature.

PHOTOGRAPHER:	FILM:
Aldo Sessa	ISO 100
CAMERA:	EXPOSURE:
6 x 7cm	⅟₁₂₅ second at f11
LENS:	LIGHTING:
45mm	Daylight only

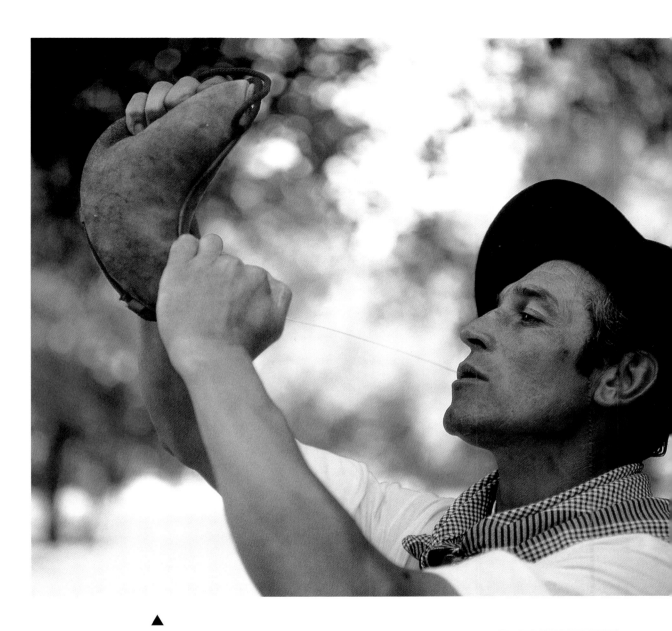

A shallow depth of field helps to lift the subject away from the background, as you can see in this image here with a gaucho effortlessly squeezing a perfectly directed stream of wine into his mouth from a traditional leather flask. With less-practised hands on the flask, however, results are often more comical.

PHOTOGRAPHER:	FILM:
Aldo Sessa	**ISO 100**
CAMERA:	EXPOSURE:
6 x 7cm	**½₅₀ second at f4**
LENS:	LIGHTING:
180mm	**Daylight only**

Directory of photographers

Jörgen Ahlström
Norr Mälarstrand 12
112 20 Stockholm
Sweden
Telephone: + 46 8 650 51 80
Fax: + 46 8 650 51 82

Pascal Baetens
W. Coosemansstrat 122
B-3010 Kessel-Lo
Belgium
Telephone: + 32 16 258 411
Fax: + 32 16 258 470

Efren V. Evidor
Unit 201 CRS Tower
President Quirino Avenue
Plaza Dilao
Paco
Manila
Philippines 1007
Telephone: + 63 2 5623791
Fax: + 63 2 5623790

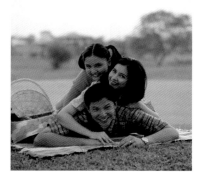

FSP (Frank Spooner Pictures)
Unit B7
16–16A Baldwins Gardens
London EC1 7US
UK
Telephone: + 44 171 6325800
Fax: + 44 171 6325828

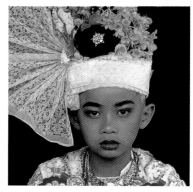

Damian Gillie
57 Warwick Gardens
London N4 1JD
UK
Telephone: + 44 181 8007397

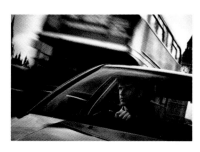

Robert Hallmann
72 Castle Road
Hadleigh
Benfleet
Essex SS7 2AT
UK
Telephone: + 44 1702 557404

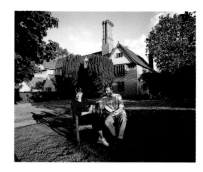

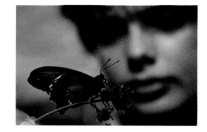

Jonathan Hilton
63 Greenham Road
London N10 1LN
UK
Telephone: + 44 181 4445882
Fax: + 44 181 4443551

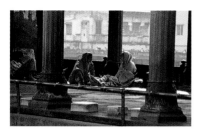

Frits Jansma
Konningsstraat 8
1811 LV Alkmaar
Netherlands
Telephone: + 31 72 5152901
Fax: + 31 72 5151885

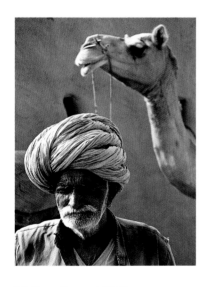

Majken Kruse LBIPP
11 East Court
South Horrington Village
Wells
Somerset BA5 3HL
UK
Telephone: + 44 1749 671571

Majken is a professional photographer with an active photographic practice

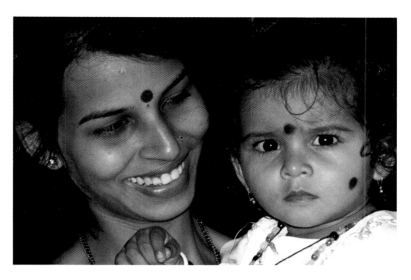

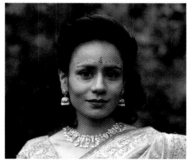

specializing in weddings and portraiture. She started her working career in front of the camera as a model. At that time, photography was more of a hobby, albeit an important one. This experience, and a natural eye for photographic composition, led her to taking up photography professionally. Majken initially concentrated on children and general portraiture before widening her photographic interests. She firmly believes that her experience in front of the camera helps her to relate to, and work effectively with, her subjects to achieve a natural look. Her creative talent, together with years of experience, are reflected in a very individual style.

Strat Mastoris
33 Byrne Road
London SW12 9HZ
UK
Telephone: + 44 181 6755281

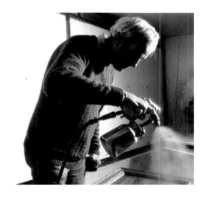

Popperfoto
The Old Mill
Overstone Farm
Overstone
Northampton NN6 0AB
UK
Telephone: + 44 1604 670670
Fax: + 44 1604 670635

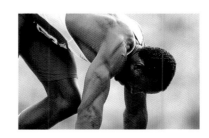

Tim Ridley
Wells Street Studios
70–71 Wells Street
London W1P 3RD
UK
Telephone: + 44 171 5805198
Fax: + 44 171 3233690

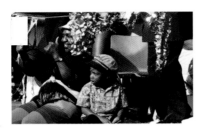

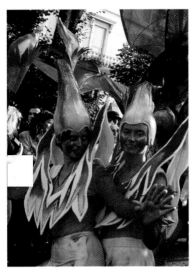

Tim Ridley is an established freelance photographer, having started in the business more than 15 years ago as a photographic assistant. In his West End studio in central London, Tim specializes in publishing, public relations, and design group clients. Recently, a series of Tim's photographs won him a place in the annual Association of Photographers competition. His favourite medium is black and white and he particularly enjoys working with both children and animals.

Llewellyn Robins FBIPP FRPS
64 Enborne Road
Newbury
Berkshire RG14 6AH
UK
Telephone: + 44 1635 42777
Fax: + 44 1635 522768

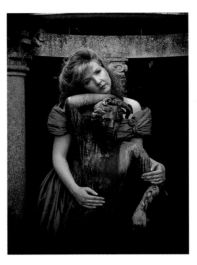

Llewellyn Robins has been photographing people professionally for more than 30 years. He is probably best known for his candid work – photographing children at play in gardens, the countryside or other outdoor locations. His preference is for a relaxed approach to photographing young people. Believing that better pictures result if you know your subjects, he always takes the time to gain their confidence before thinking about picking up the camera. Llewellyn has a fellowship in photography from both the British Institute of Professional Photography and The Royal Photographic Society. He has also lectured on his individual style and approach to photography in both the UK and the United States.

Aldo Sessa
Passaje Bollini 2233
CP 1425 Buenos Aires
Argentina
Telephone: + 541 8063796/97
Fax: + 541 8039071

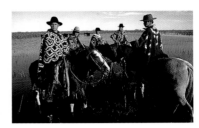

Edward Tigor Siahaan
J1 Tebet Timur Dalam IV/54
Jakarta 12820
Indonesia
Telephone: + 62 21 8312163
Fax: + 62 21 3149828

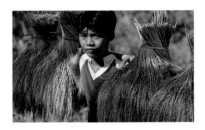

Linda Sole
33 Coleraine Road
London SE3 7PF
UK
Telephone: + 44 181 8588954
Fax: + 44 181 7398840

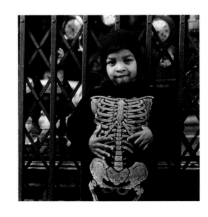

Born in 1943 in County Durham, Linda Sole now lives and works in southeast London earning her living as a freelance photographer concentrating principally on reportage and

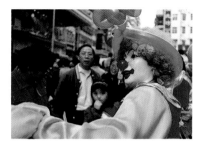

photo-documentary. Linda joined the Independent Photographers' Project in 1983, organizing workshops and photographic local events. Teaching photography has been a strand running through Linda's career, and she has taught and lectured on photography at various schools and colleges in Britain and abroad. She was also resident photographer at Blackheath Concert Halls between 1991 and 1993, where she held two exhibitions of her work. She also taught photography in France while working for a theme holiday company. As well as exhibiting regularly at Hays Gallery in Deptford, London, Linda is also the winner of numerous photographic competition awards.

Bert Wiklund
PO Box 142
DK-7330 Brande
Denmark
Telephone: + 45 97 18 23 35
Fax: + 45 97 18 39 13
Bert Wiklund was born in Sweden and has been working as a professional photographer in Denmark for the last 21 years. Bert's academic background is in economics and social science and he has no formal training as a photographer – he says: 'You can't yet get a formal degree in photographing nature anywhere in the world.' With his vast experience in, and love of, nature photography, his current client list is mainly composed of specialist magazines and books, but his interests also extend to the world of advertising photography. 'Everybody likes to have a green image today,' Bert wryly remarks.

Bert finds nature photography the most wide ranging of the photographic disciplines, extending, in his own words, 'from bacteria to

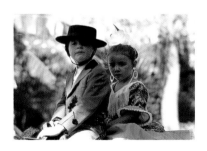

galaxies'. To cope with this spread of subject matter, Bert finds himself using a range of different camera formats: a 35mm Nikon, a medium format Pentax, and even a half-plate camera when detail and quality are paramount. For more specialized imagery, his arsenal also contains panoramic and underwater cameras.

'Pictures of nature and of animals are difficult to predict and plan for in advance. You have to grab each opportunity as it arises.' Today, Bert's policy has created a photo archive of more than 150,000 pictures from every continent on the planet. And to make picture selection as easy as possible for clients, he can send a 10,000-picture compact disc designed to give a flavour of the material available.

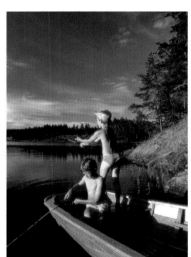

Acknowledgements

In large part, the production of this book was made possible because of the contributions of the many photographers featured, some of whom permitted their work to be reproduced free of charge, and the publishers would like to acknowledge their most valued contribution.

The author and publishers would also like to thank the many individuals and organizations who gave their support, technical assistance and services during the production of this book, in particular Brian Morris and Barbara Mercer at RotoVision SA, Anne-Marie Ehrlich and Samantha Larrance at E.T. Archive, and all of the manufacturers and distributors whose equipment appears in this book.

All of the illustrations in this book were drawn by Brian Manning.

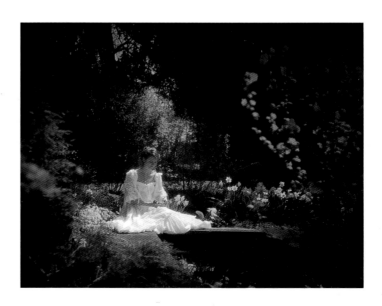